KIRKHAM &
AROUND
THROUGH TIME
Martin Ramsbottom

AMBERLEY PUBLISHING

First published 2013

Amberley Publishing
The Hill, Stroud, Gloucestershire, GL5 4EP
www.amberley-books.com

Copyright © Martin Ramsbottom, 2013

The right Martin Ramsbottom to be identified as the
Author of this work has been asserted in accordance with
the Copyrights, Designs and Patents Act 1988.

ISBN 978 1 4456 1653 7 (print)
ISBN 978 1 4456 1672 8 (ebook)

British Library Cataloguing in Publication Data.
A catalogue record for this book is available from the
British Library.

Typesetting by Amberley Publishing.
Printed in Great Britain.

Introduction

Situated in the south of the Fylde of Lancashire, Kirkham was the predominant settlement in the area for centuries. The first known occupants were the Romans who, in AD 79, established a fort on high ground to the east of what was to become the town centre. By the end of the seventh century, according to tradition, the first church had been established and was later recorded in the Domesday Book, which was compiled on the orders of the Norman King William I in 1086. It is this document that provides the first written evidence for the town's existence. The ownership of the Manor of Kirkham, created by the Normans, then passed through several hands until, by 1280, it was in the possession of the Cheshire Abbey of Vale Royal. The town was then firmly established as the focal point of the area. Its church of St Michael catered for the spiritual needs of a large parish of fifteen surrounding hamlets, including Clifton, Freckleton, Newton, Warton and Wrea Green. Its weekly markets and its craftsmen provided for their commercial needs and, religious observance fulfilled or the business of the day transacted, its inns provided welcome rest and refreshment.

In 1296, Vale Royal granted Kirkham a charter as a seigneurial borough, which gave its citizens a measure of control over their own destiny, and provided not only for the administration of justice but also for control of trading within the town, as well as early forms of consumer protection by way of the Assize of Bread and Drink of 1266 and the Assize of Weights and Measures, although the abbey retained the rights to the market and its associated annual fairs, rights that are retained by the present Lord of the Manor.

While the town, in common with the rest of the Fylde, had always been a farming district, in Kirkham itself the manufacture of sailcloth became increasingly important and by 1800, the industry was a major employer in the town, with its factories, warehouses and large houses of the entrepreneurial families dominating the streets. Cotton also came to the town, and mills were erected to the west of the town centre, adjacent to the railway that had opened in 1840. The town's importance to the area was further enhanced when, following the passing of the Poor Law Amendment Act in 1834, the town's parish workhouse was adopted as the workhouse for the newly established Fylde Poor Law Union, which stretched across the whole of the area's twenty-three townships.

The opening of the railway, the subsequent development of the seaside resorts of Blackpool, Fleetwood and Lytham, and the growth of nearby Preston as a major cotton town, together with

the progressive division of the large ecclesiastical parish throughout the nineteenth century, all combined to diminish Kirkham's status in the area. Agriculture remained important, but the flax industry declined and finally came to an end in the 1890s. Cotton, in common with the industry in Lancashire as a whole, also progressively declined, although it was not until 2002 that the last mill in Kirkham finally closed its doors. On the other hand, light industry developed on land to the south and west of the town, and there has been considerable housing development on the outskirts. Living accommodation of a different kind was provided by the opening of Her Majesty's Kirkham Prison on the site of the former RAF station to the south of the main Preston to Blackpool road.

Clearly, there has been considerable change in the nature of the town, and it now functions largely as a dormitory town for people working in Preston, the coastal resorts and farther afield. However, it continues to thrive in its modern role and new housing is continuously springing up. Its markets flourish, new shops open, although there is the occasional closure, and the community spirit – fostered by an active town council, the Kirkham Business Group, the Lord of the Manor, churches, schools, voluntary associations and public services – is just as strong as ever it was.

As for the villages, some, Freckleton for example, have seen change on a scale comparable to that noticed at Kirkham. Its cotton mill and rope works have long gone, to be replaced by houses and bungalows. Down the road at Warton, the British Aerospace complex built on the site of a Second World War American Air Force base is a major employer in the area. Lund, too, has its industry in the form of the British Nuclear Fuels plant. Others, in particular Treales, Westby and Wrea Green, remain largely unchanged, apart from yet more housing. It is possibly at Wesham that the greatest change occurred. When the railway arrived in 1840, the hamlet was little more than a few scattered farmsteads. The cotton industry was quick to take advantage of the availability of the new form of transport, building two large mills adjacent to the station on the Wrangway, now Station Road. The station itself was relocated to its present position following a major expansion of the railway track towards the end of the century. Latterly, however, its experience echoes that of its immediate neighbour and while there is some light industry, new housing dominates the landscape.

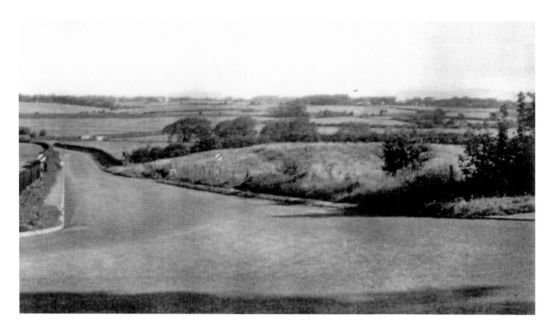

Carr Hill – Treales Road, Looking North Towards the Railway

Kirkham experienced considerable housing growth in the years following the end of the Second World War, and these images show development at the east end of the town beyond its traditional boundaries. Homes are largely a mixture of dormer and true bungalows on the left of Treales Road, with streets being named after Lancashire rivers: Lune, Wyre and Ribble. On the right, houses predominate on roads whose names have historical connections, such as Vale Royal and Danes Close. Building work on Pennine View, beyond the grey car to the right, revealed pottery from the adjacent site of the town's Roman fort.

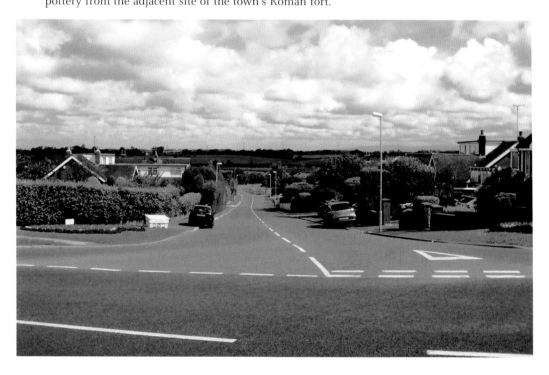

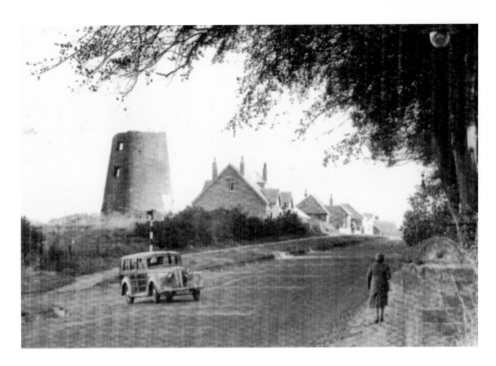

Carr Hill – the Windmill

The windmill dates from the early 1800s, when it replaced an earlier wooden structure. By the end of the century, it had become derelict, and it later served as a playground for boys of the area and a meeting place for a Wolf Cub Pack, until being restored and converted to a private dwelling. More post-Second World War housing is visible on the main road. Note the boundary wall and trees of the Carr Hill House estate on the right of the earlier picture. An Austin timber-framed shooting brake emerges from Treales Road, its steep junction providing practice for hill starts for learner drivers.

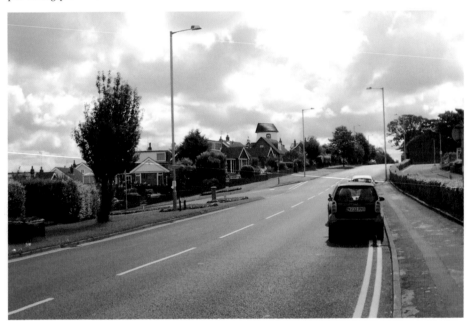

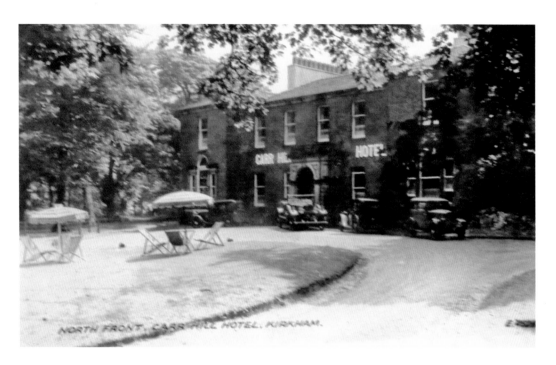

Carr Hill House

For many years, this large late eighteenth-century house was the residence of the Lord of the Manor of Kirkham. He later converted it to an hotel and strip-tease club in the 1950s, but the venture failed and the building was demolished and the site sold for building land. The stone wall on the left is all that remains of the estate, while Dowbridge Way, seen in the middle distance on the modern image, occupies what was the front lawn of the old house. On the left, the small houses clearly mark the eastern extent of the old town.

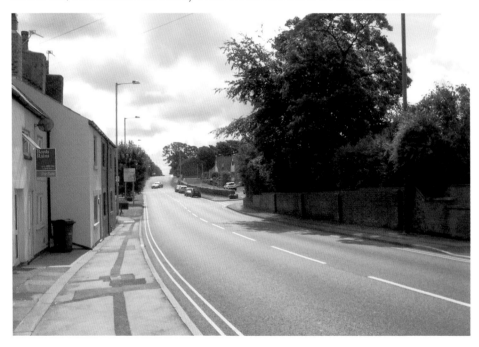

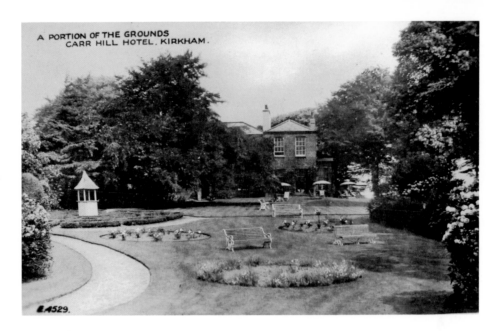

A PORTION OF THE GROUNDS
CARR HILL HOTEL. KIRKHAM.

A529.

Carr Hill House, the Grounds

The grounds of Carr Hill House were extensive and stretched to Freckleton Street, along Dowbridge and to the A583 Kirkham Bypass. In the interwar years, the Lord of the Manor established a racecourse on this estate, an enterprise that enjoyed a degree of success, but efforts to revive meetings after the end of hostilities failed and when the estate was sold, part of the land adjacent to Freckleton Street and the bypass was used to build Carr Hill Secondary Modern School, now Carr Hill High School. The original buildings, shown here in the modern image, have now been considerably extended as student numbers have risen.

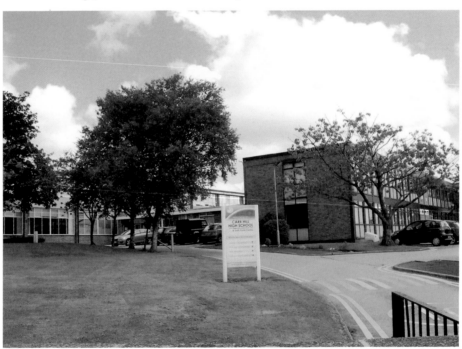

Preston Street from Carr Hill

The boundary wall of the Carr Hill estate, replaced by a hedge when the land was developed for housing, can be seen on the left of these images. Carr Dene Court on the right occupies the site of an apple orchard, and beyond them, the older houses marking the extent of the 'old' town (see page 7) can be seen. Children pose in the middle of the road. The vehicle in the later image, the modern version of the shooting brake, is turning into Treales Road, shown on page 5.

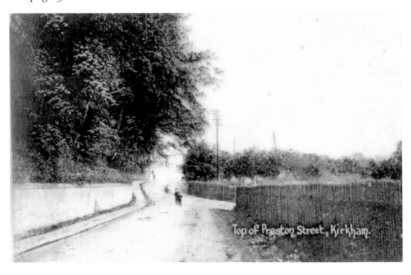

9

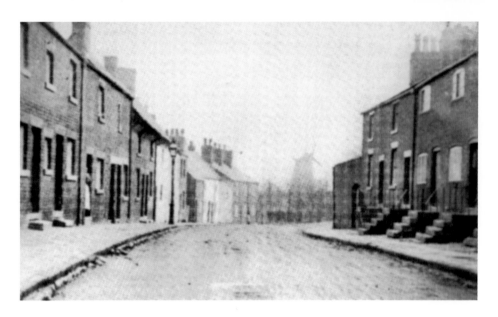

Preston Street – Top of the Hill, Looking East

On the right are the handloom weavers' cottages, built by the father of William Segar Hodgson, who was not only a considerable benefactor to the town, but also a member of the Board of Guardians for the Fylde Poor Law Union. These houses, now much refurbished and their half-cellar windows bricked up, are still occupied. In the left foreground of the old image, a housewife watches the photographer at work from the doorway of one of a row of similar properties, now replaced by modern housing. Beyond is one of Kirkham's early gas lamps, while in the distance, the windmill provides a focal point.

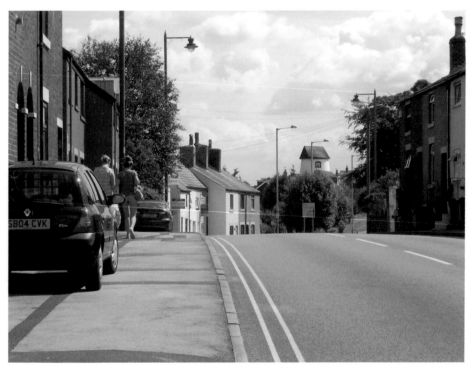

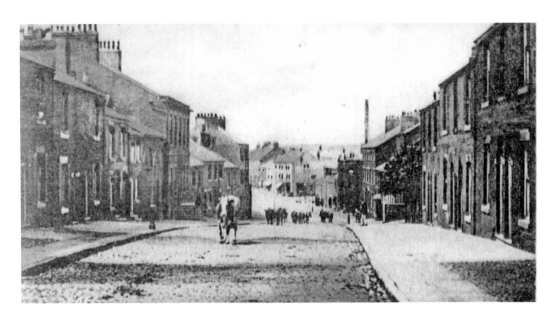

Preston Street – Looking Towards the Market Square

The cows in the older image recall the town's agricultural connection. These two, or a couple very like them, were regularly to be seen in the main street of the town as they were herded from their shippon on Poulton Street to their pasture on the outskirts. The later image clearly shows the handloom weavers' cottages on the left. On the same side, halfway down the hill, Hillside can be seen. On the right, the cars parked on the footpath present a contrast with the older image.

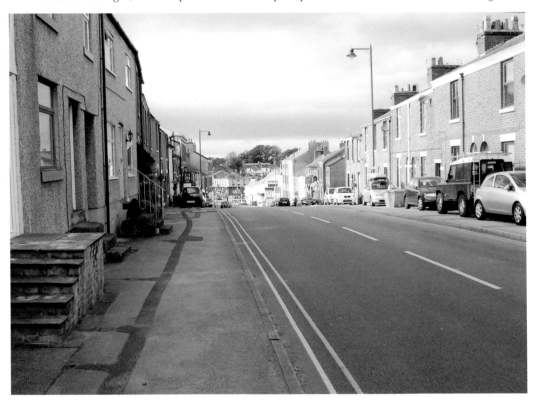

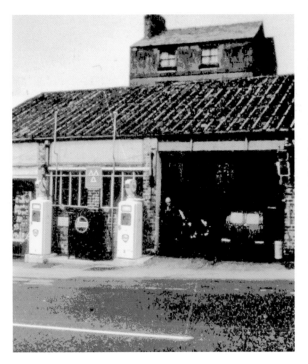

Preston Street – Whalley's Garage

At one time, the house visible in the earlier image and its grounds belonged to one Hornby Roughsedge, a bailiff of Kirkham and flax manufacturer. The front garden later became one of a number of motor garages in the town that, from the early twentieth century, supplied an ever-increasing number of motorists with their essential stores, such as oil, petrol and water, and was originally operated by Bagnall father and son. Changes in trade patterns and legislation controlling the sale of petrol led to the eventual closure of the business, and both garage and the old house were demolished, and a new property was erected on the site. The figure in the old picture is Mr Harold Whalley, the last owner of the business.

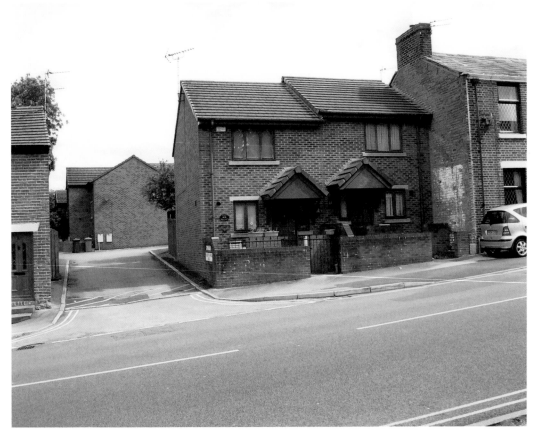

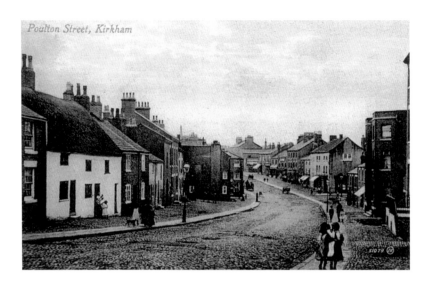

Poulton Street, Kirkham

Preston Street – Looking West

In the distance, both photographs show the encroachment on the market square, where tall buildings extend beyond the earlier building line. On the left, older houses still have their thatched roofs and, at the bottom of the street, one of the town's water pumps can be seen. On the right, Dr Shepherd's house has gone but John Birley's, with its sideways steps, is just visible. As usual, children wonder what the photographer is doing. At the junction of the market square and Poulton Street, older buildings that were replaced in the 1960s can be seen.

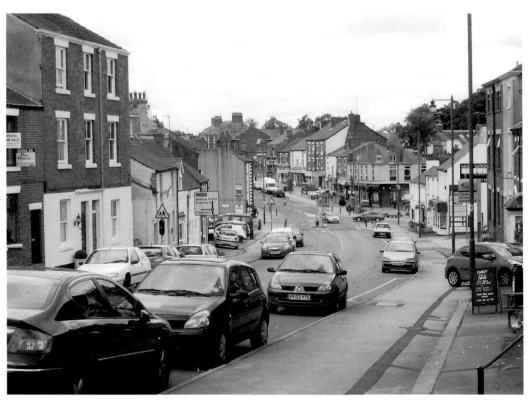

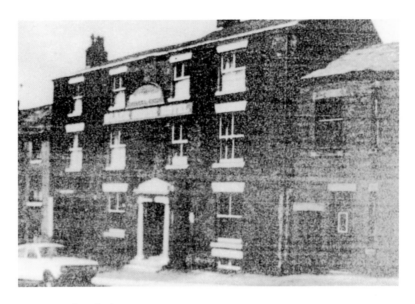

Preston Street – the Black Horse Inn

One of the town's oldest public houses, and probably originally a coaching inn for travellers between Preston and the Fylde coast, the Black Horse was scheduled for major refurbishment. A survey revealed that the foundations were none too substantial, and demolition and rebuilding was decided upon. While the work was under way, a portakabin in the yard enabled the licence to be maintained and the regulars to be watered. The older patrons still remember the formidable landlady, a Mrs Reeder, who was succeeded by her son. The car in the older image is a Morris Marina, one of the last models to be produced by the ill-fated British Motor Corporation.

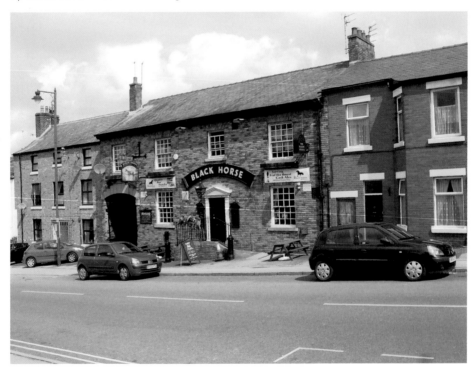

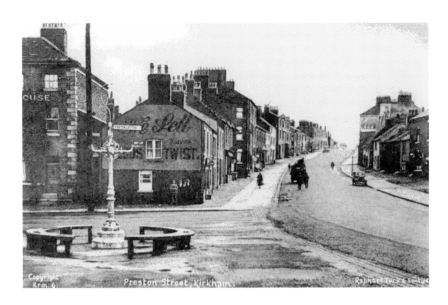

Preston Street from the Market Square

While little has changed on the south side, apart from external refurbishment, Dr Shepherd's house, with its bay windows, has been replaced by the Fylde Motor Company's premises on the left-hand side of the street; John Birley's house with its sideways steps is now three separate houses; the Black Horse has been rebuilt and, towards the crest of the hill, Whalley's garage (see page 12) has been replaced by yet more private houses. The gable end on the left in the older picture carries an advert for Wood's Tobacco Twist, unlikely to be allowed in 2013.

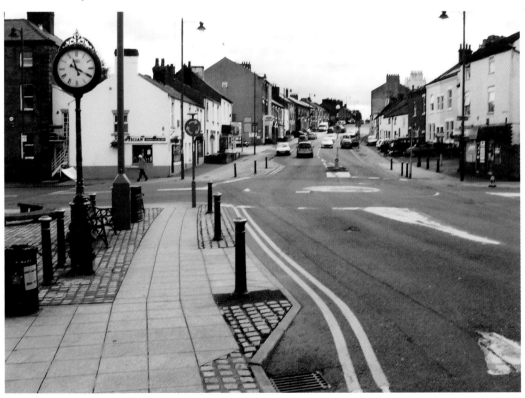

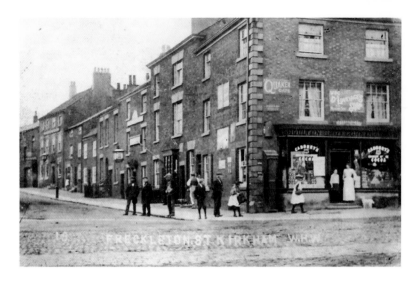

Market Square – the South-West Corner

On the corner, the grocer's shop that sold Lovelace's soap, Quaker Oats and Cadbury's cocoa, has now become a branch of Barclays Bank. Previous owners included members of the Boulton family, one of whom was bandmaster of the town's brass band, and Jimmy Johnson, founder of Crown Crisps. Looking up Freckleton Street, the building with a bay window is now a popular fish and chip shop, while the Ship Inn, now defunct, and the buildings beyond are occupied by small business premises in a row that stretches as far as the Post Office Hotel.

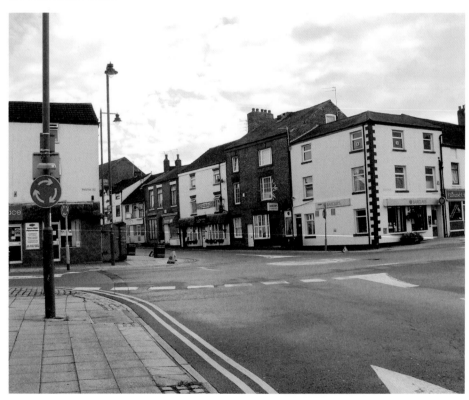

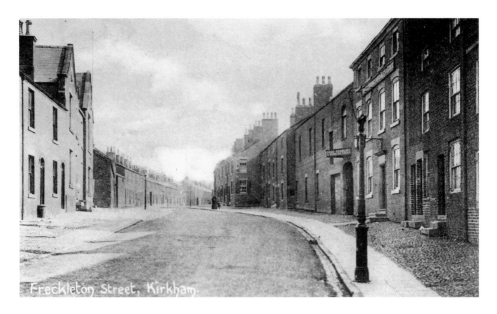

Freckleton Street

Looking at the older image, on the east side of the street is the town's courthouse and police station, while beyond is a row of cottages and the entrance to Hornby Court, built by the Hornby family for the workers in their nearby sailcloth factory. The police station was replaced by the modern building immediately to the south, which is just visible in the later photograph. Opposite and beyond the Post Office Hotel, its car park and Amounderness Court – accommodation for some of the town's elderly citizens – occupy the site of a mill or warehouse for the textile industry, which is believed to have been destroyed by fire. The cobbles in the carriageway have been replaced by tarmac, and the gas lamp by an electric version.

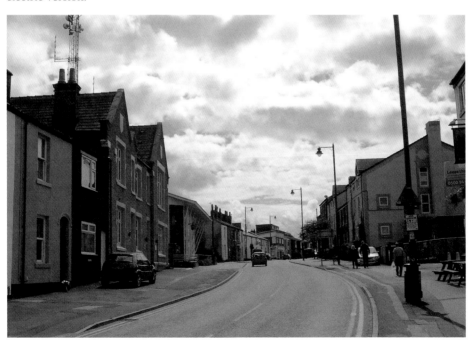

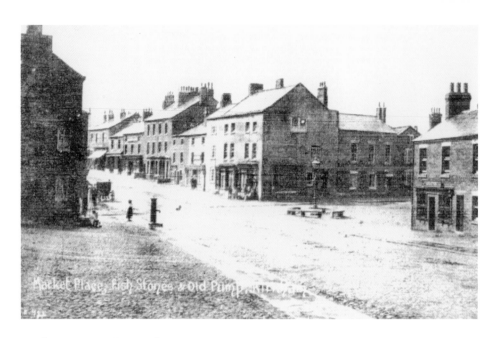

Market Square – the North-West Corner

On the corner, the large house that was owned by the Hornby family, which was later the town's courthouse and then a seedsman's shop, was demolished along with the rest of the square and adjacent properties in the 1960s. All, including a large house owned by the Bowdler family, were replaced by the concrete and glass structures shown in the later image, a style of construction popular at the time but now rather out of favour. Both images show the town's lamp, which had been removed for a period as it was not thought to be in keeping with a new street lighting system. Wiser counsels subsequently prevailed. One of the town's several pumps, through which the citizens drew their water, can be seen in the foreground of the older photograph.

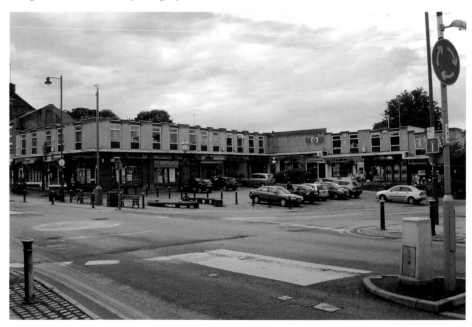

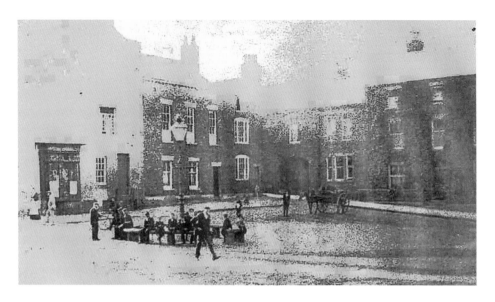

Market Square – More Views

These images look towards the north-west corner of the square and Eagle Court, the site of the public house kept by Isobel Birley, the benefactress of the Free Grammar School. The older image shows one of the town's water pumps in the left foreground, while the more recent one shows demolition of the square in progress. Vehicles parked on the cobbles include a Ford Anglia, a Ford Cortina and a Hillman Husky. The bus shelter stands on the site of the pump and, across the road, two cub scouts enjoy the goodies they have just purchased from Mrs Kirby's sweet shop, which is now an optician's office.

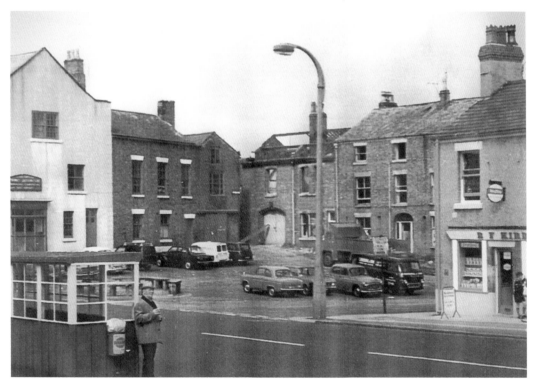

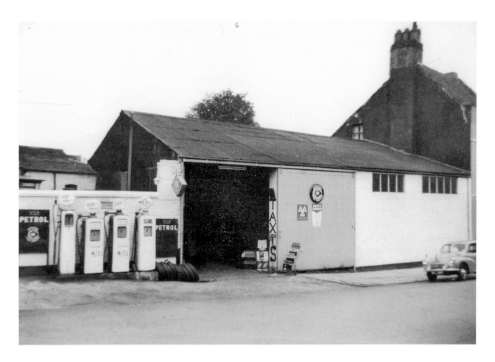

Church Street – Jackson's Garage

Yet another of the town's garages, most of which have fallen victim to changes in legislation and trading patterns. This enterprise occupied the site of a public house, the Bluebell Inn. As can be seen, a taxi service was offered and Dunlop tyres and VIP petrol were on sale. The proprietor also operated coaches and charabancs conveying holidaymakers to the seaside. The town's public lavatories and the access to the rear of the shops in the square now fill the space. The gable on the right belongs to a building that was formerly a girl's school.

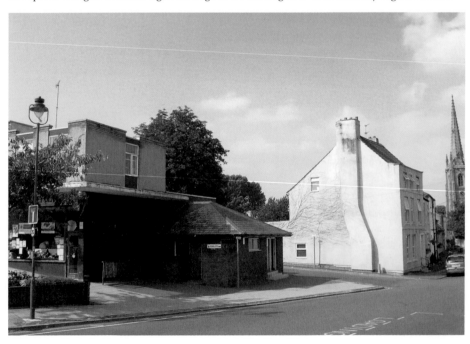

Church Street – Ash Tree House

A mid-eighteenth-century rebuilding of an earlier house, Ash Tree House was the home of notable Kirkham families, including the Langtons, the Shaws and solicitors W. J. Dixon and Richard Moore. After the First World War, the Parochial Church Council of St Michael's church purchased the property as a memorial to the men of the parish who died serving their country – hence the name Memorial Church House shown here. The facilities offered included a library and billiard room. The church subsequently leased the building to the Ministry of Labour, who opened the town's Labour Exchange and other public offices there. When it ceased to be needed for government purposes, Ash Tree House was sold to a doctor's practice that restored the original name, as well as some of the internal fittings.

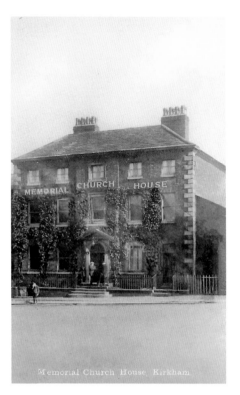

Memorial Church House, Kirkham

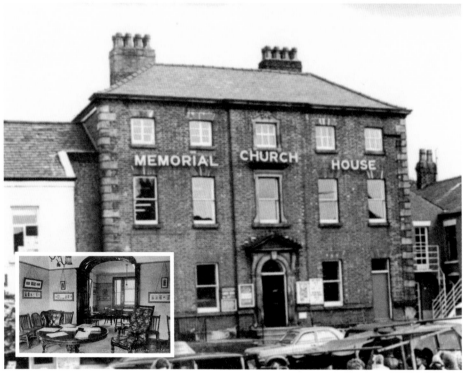

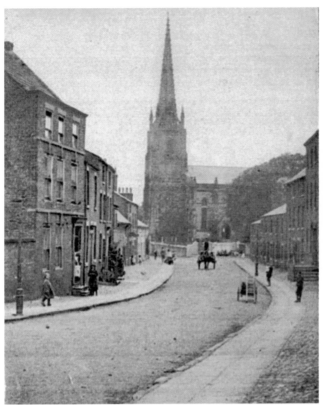

Church Street from the Market Square

The Anglican parish church of St Michael and the properties on the west side (left) remain, externally at least, much as shown in the older image. The houses include some of the town's oldest properties and two that were dame schools. On the opposite side of the street, older houses, including the large property owned by the Birley family, have been replaced by Ançenis Court. This cluster of small houses, built for older residents of the town, was named after one of Kirkham's two twin towns, the other being Bad Brückenau.

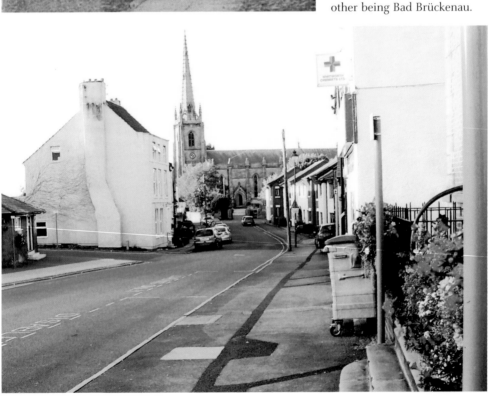

Church Street –
the North-East End

Taken from the church gates, these images show the northern end of Church Street with the older properties that were replaced by Ançencis Court. By the time of their demolition, the old family home of the Birley family had been converted into a motor car repair garage and flats. Immediately behind, No. 4, latterly a doctor's residence and surgery, and Ash Tree House, home of the Langtons and the Shaws, who were other prominent families in the town's history, are just about visible.

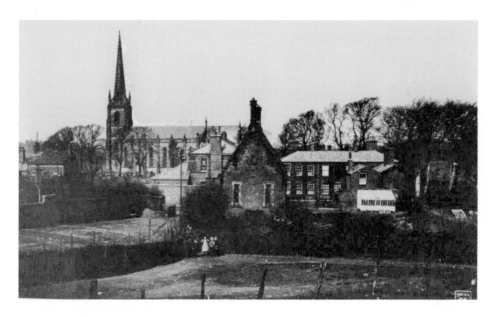

Church Street – the Church and the Schools

Until the early twentieth century, the Free Grammar School and the Anglican Church School stood adjacent to each other, and in close proximity to the church itself, with which they were both closely connected. In the foreground is the hall of the grammar school, with the school buildings themselves behind and to the right. To the left of the hall, the church school itself in its 1850s building can be seen. The grammar school moved to Ribby Road in 1911, and the buildings on the old site were all demolished, although the headmaster's house remained in use as a private dwelling until the 1930s. The church school was progressively replaced by the modern, single-storey building shown in the more recent photograph.

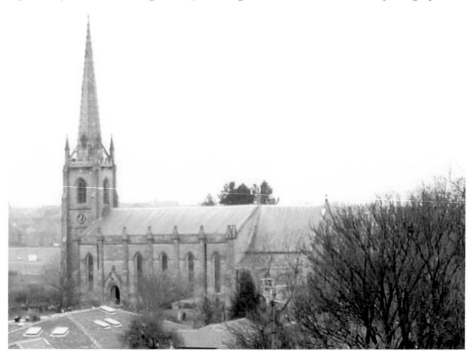

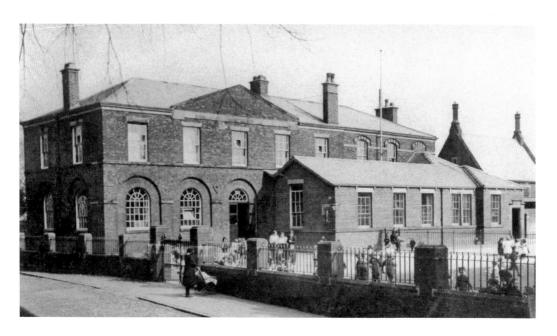

School Lane – St Michael's School

Here, the original church school building can be seen; it was erected in 1813 following the decision to open a new school 'for the instruction of poor children'. Behind this small structure is the 1850s building where girls and boys were taught separately, each having their own entrance and playground. To the right of these buildings, the hall attached to the grammar school is visible. As can be seen in the modern photograph, all these have gone. The hall was demolished following the grammar school's move to Ribby Road, while the church school erected a modern hall, as seen on the right of the photograph, and then progressively replaced the 1850s two-storey structure with a single-storey block of classrooms and other accommodation. Note, however, that the old boundary wall and fence remain.

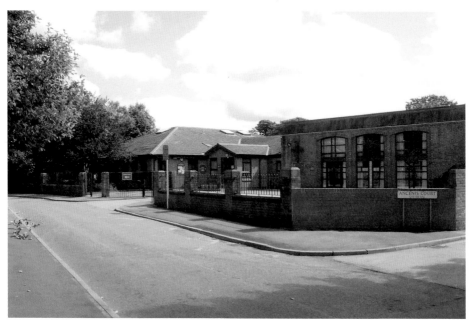

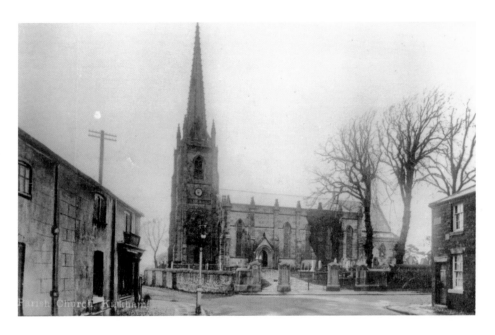

Church Street and St Michael's Church

The church was rebuilt from 1822 onwards, largely on the foundations of the sixteenth-century edifice. While it has undergone little external change over the years, there has been considerable internal modification, including the removal of the north and south galleries. At the end of the street on the left, the end property, shown on the early image as a shop where sweets and ice cream could be bought, is now a private dwelling, while on the opposite side of the road, the houses shown on page 23 can be seen before demolition.

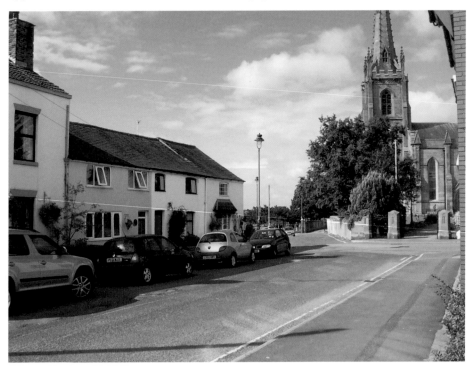

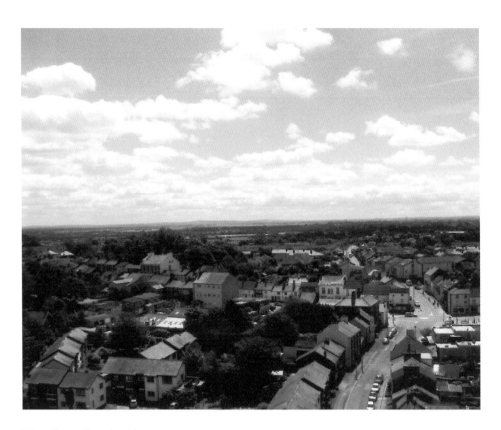

View from the Church Tower

The principal changes shown here are the replacement of houses on the left side of Church Street by Ançenis Court, and the rebuilding of the shops in the then market square. In the distance, on the corner of Freckleton Street, the old three-storey building was knocked down after it debated matters with a large wagon. Serving a variety of uses over time, it finished its days as a comic and second-hand bookshop. On the modern image, the rear of John Birley's house on Preston Street, Hillside, almost opposite and on the right of Freckleton Street, and Amounderness Court can all be seen.

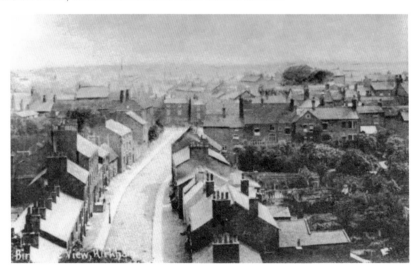

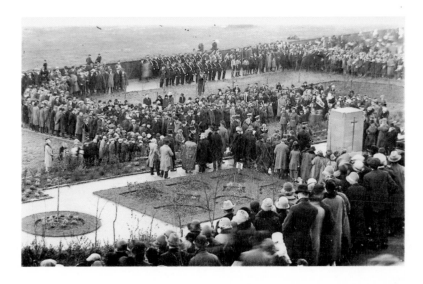

Church Street – the War Memorial

The memorial, on the path from Church Street to Barnfield, was dedicated in 1926 and the early image shows the ceremony in progress in the presence of civic and military dignitaries, including the vicar of Kirkham, the Revd W. T. Mitton, and the headmaster of the grammar school, the Revd Creswell Strange. The North-West Film Archive has a record of the ceremony. It is said that there is a tree in the garden for every man of the town who was killed in the First World War, and some of these are clearly seen in the later image. Much restoration work, prompted to some extent by global hostilities, has recently been undertaken.

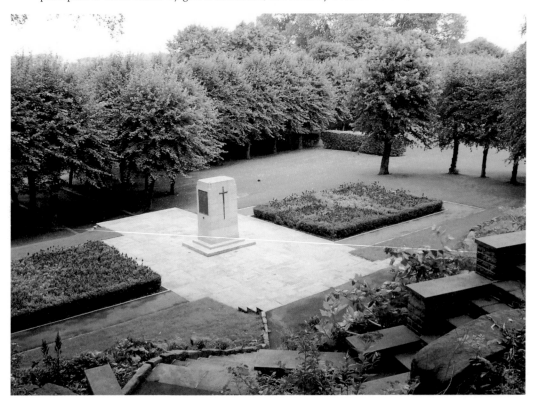

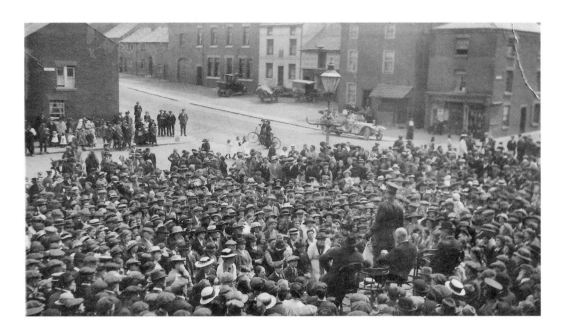

Church Street – Recruiting and Recruited – Great War

The town's war memorial was erected following the end of the First World War. Here, two images are clearly connected with Kirkham's contribution to the conflict. The first appears to be a recruiting campaign in the Market Square. The crowd is being addressed by a military man, next to whom is a bald-headed gentleman, possibly the Revd Canon Mitton, the vicar of Kirkham. The second, taken in front of what might be the old vicarage on School Lane, shows some of the town's recruits. A contemporary newspaper cutting refers to the fact that 120 Kirkham men marched to Preston carrying a card on which was lettered 'For Kitchener from Kirkham'. On arrival, they enrolled at the recruiting office at the Public Hall.

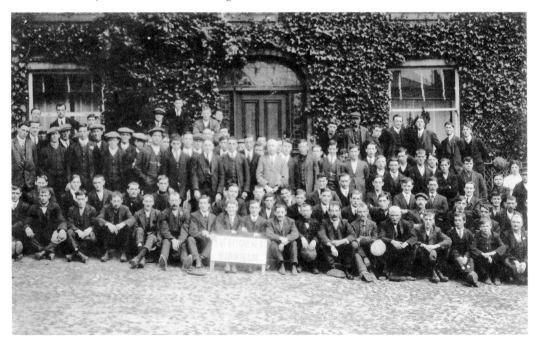

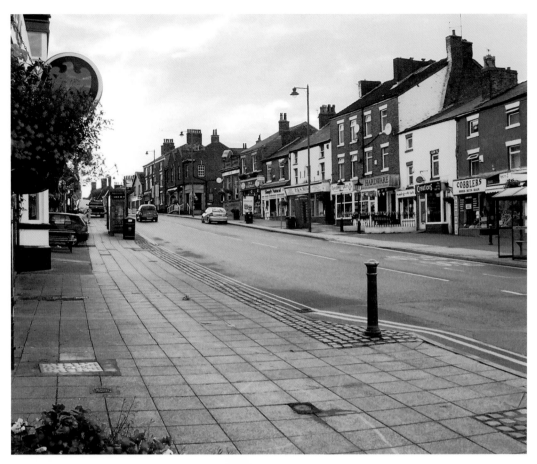

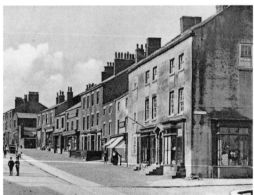

Poulton Street from the Market Square
Small boys no longer pose in the middle of the road for the benefit of the photographer. Many of the older buildings remain, although with new shopfronts. However, Hornby's house on the corner has long since disappeared, while in the middle distance, Birley Street has been opened up and the offices of the Fylde Water Works replaced by a bank. An interesting feature in the modern photograph is the traditional red telephone kiosk, a breed now largely replaced by glass and steel structures.

Poulton Street – the Kirkgate Centre

The work of local entrepreneur William Harrison, the Kirkgate Centre replaced a row of miscellaneous properties, including a travel agent's, seedsman's, ladies' dress shop and, in the property by the steps, an ice cream shop owned by a Mr Mellor, who, as far as is known, was no relation to the Mellor of Milbanke House and Mellor Road. The gable end on the older image is the property on the far side of Kirkgate itself, and is just visible in the modern photograph. Were the smaller houses the homes of handloom weavers? Their cellars suggest that this might be the case.

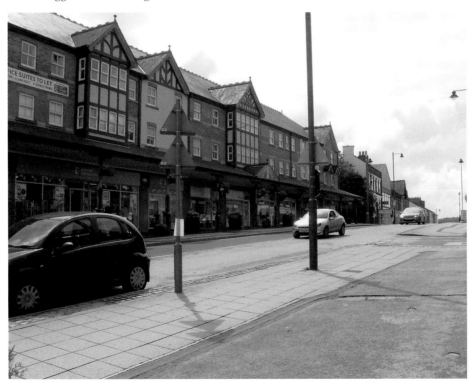

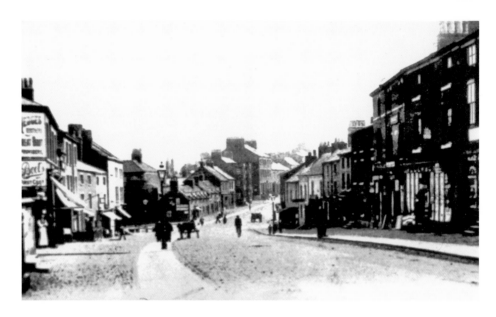

Poulton Street – Looking Eastward

Taken from the crest of the hill, these images show the eastern half of Poulton Street with Preston Street in the distance. The site of the Kirkgate Centre (see page 31) appears on the left, while lower down, the Queen's Hotel has yet to be rebuilt. Opposite, on the corner of Birley Street, the premises now the HSBC Bank appears to be a shop whose proprietor stands in the doorway, while a lone cyclist pedals away on the 'wrong' side of the road. In the distance, Dr Shepherd's and John Birley's houses stand next to a building that is now an estate agent's, but was then the home of the Fylde Seed & Guano Company.

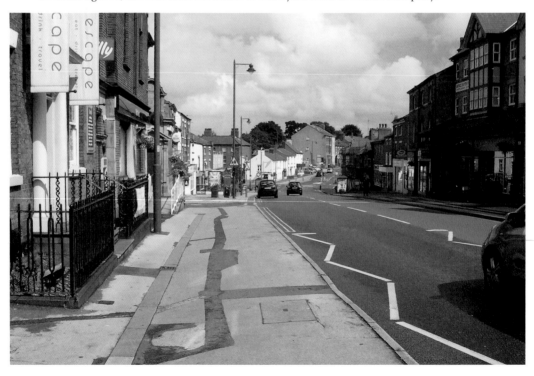

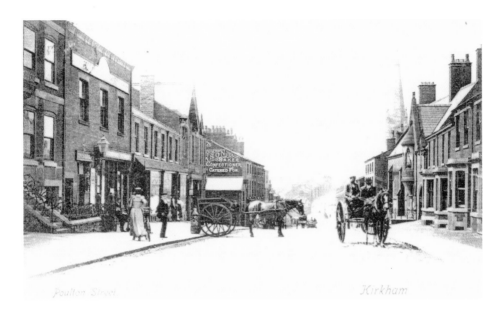

Poulton Street – Looking Westwards

The camera has swung through 180 degrees to look towards the town end. The Langton Charity Girls School, now Lloyds Bank and the Congregational church, now the United Reformed church, are seen on both images. On the north side (right), one of the two shops is now the town's oldest bookshop, but the properties below, behind which were the shippons (*referred to on p. 11*), have now been replaced by residential property. On the left, almost the whole row of shops was owned by the Fylde Co-operative Society, whose activities included a cinema.

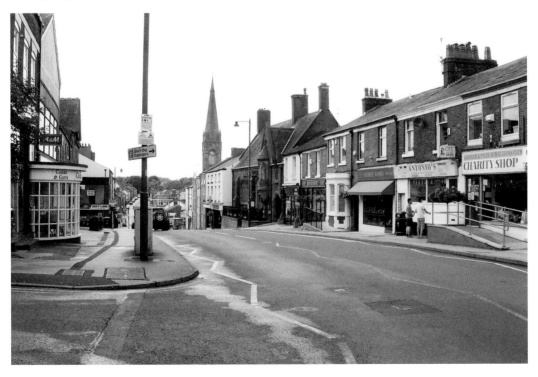

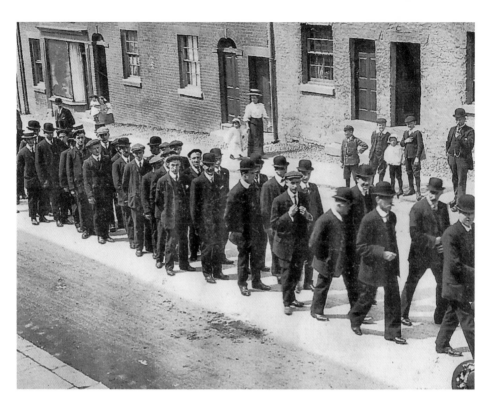

Poulton Street – Mr Parkinson's Farm

It is the buildings rather than the procession that are of interest here. In the older photograph, a lady in a long skirt stands near the ginnel that led to the rear of Mr Parkinson's house, where shippons provided a home for a couple of cows, probably those seen at the top of Preston Street on page 11. As the later photograph reveals, the old houses have been replaced by modern dwellings. The chemist's shop, now a podiatry clinic, was one of the oldest businesses in the town.

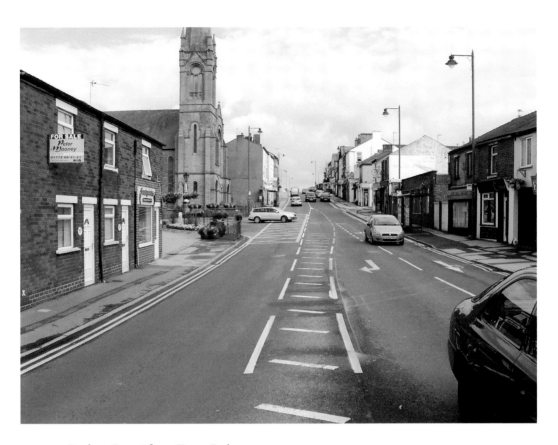

Poulton Street from Town End

The Queen Victoria Jubilee monument is shown in the early image in its original position. Subsequently relocated at least twice, it is presently located at the entrance to Mill Street. Two of the town's inns, the Swan and the Gun, appear on the early image. Only the Swan (seen on the left) still trades, while the Gun was converted to shops and offices. On the left of the older image, a third hotel, the St George, can be seen.

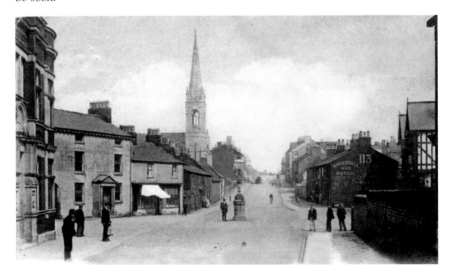

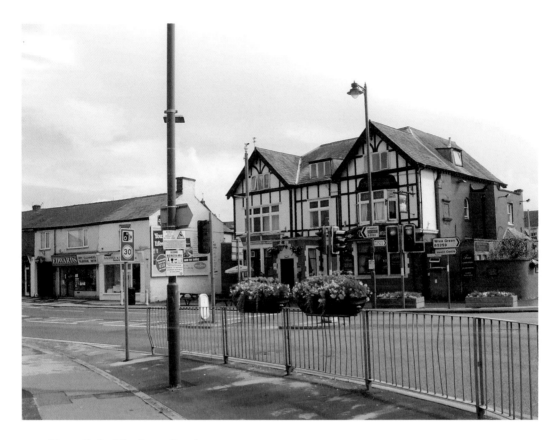

Town End – The Swan Hotel

The Swan Hotel is thought to have been named after a Mr Swan, possibly the landlord, rather than the bird. The original building is shown to be thatched and to have stables attached. The present structure dates from the late nineteenth century. On a scale similar to that of the nearby St George Hotel, one wonders what prompted the owners to erect two hotels of such relative magnificence in the town, and so near to each other. Was there some entrepreneurial rivalry?

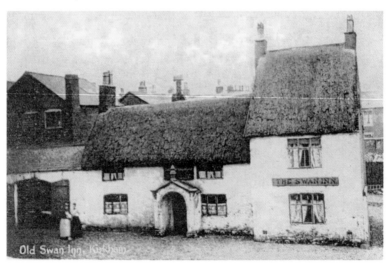

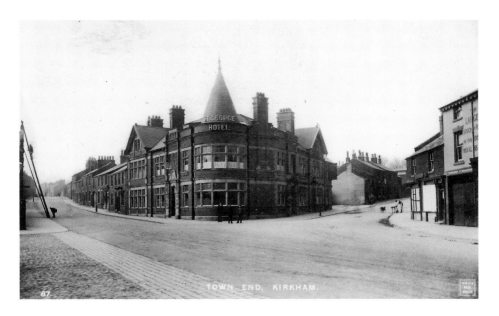

Town End – the St George Hotel

Across the road from The Swan Hotel stood the St George Hotel, locally known as 'the George'. Possibly contemporary with the rebuilding of The Swan, the building appears here with its original cupola. While The Swan is a rebuild, it is possible that the George was erected on the site of older houses, as when it was demolished in the winter of 2013 an older roofline incorporating a chimney was revealed on the adjacent house in Moor Street, suggesting the previous existence of domestic dwellings. Following demolition, a block of apartments, shown here approaching completion and similar in style to those built on the gasworks site (see page 38), was erected.

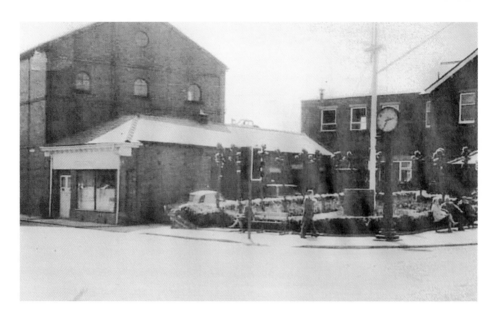

Town End – the Gasworks

Opened in the 1840s, largely on the initiative of the Birley family, the Kirkham Gasworks served the town until the supply was regionalised and supplies were drawn from Marton. The site was then occupied by a builders' merchants. Following the closure of the business, residential accommodation named Church View was erected on the land and on the adjacent space that originally housed the offices of the North-West Electricity Board and, latterly, the Kirkham Citizens' Advice Bureau. There is no evidence for the rumour that the name Gasworks Court was originally suggested for the new homes.

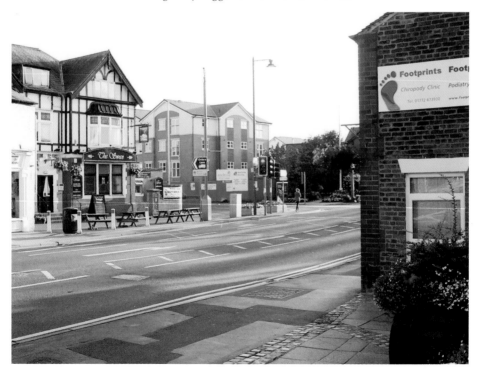

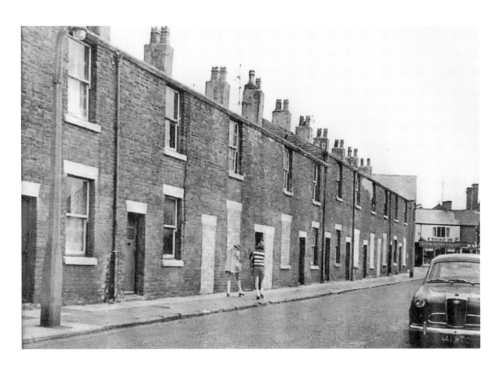

Mill Street

So-called because the street led to Birley's mill, which was situated at the northern end, little, if anything, remains of the original street, although the name has been retained. The houses on the east side, along with a brush factory, have long since gone, and the whole of it has disappeared under Morrison's supermarket and its car park. The shops on the south side of Poulton Street, which are just visible in the distance, provide a common factor.

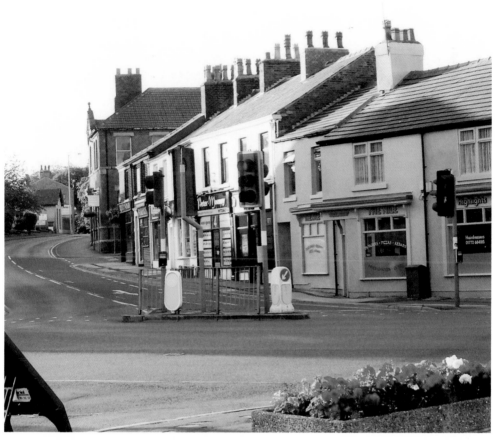

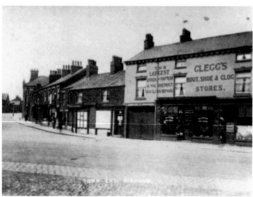

Station Road from Town End

The early buildings remain for the most part, although their use has in some cases been changed. Cleggs' shoe shop, formerly the Gun Tavern, and now a professional office, still has double doors giving access to the rear yard, where it is presumed there was stabling for horses. The offices of Dixons solicitors can still be seen on the north side of the street, while in the distance, the spire on the 1860s Fylde Union Workhouse disappeared when the building was demolished in the early 1900s.

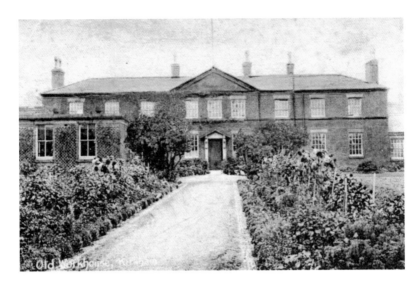

Station Road – the Workhouse

Built in the 1860s to replace an older Kirkham Township workhouse, the new structure served until just before the First World War when a new workhouse was opened on Derby Road, Wesham (see page 65). The 1860s building was then demolished and new buildings, the Cottage Homes for the accommodation of orphaned and neglected children, were erected on the site. The buildings consisted of three houses fronting onto Moor Street for the accommodation of the children themselves, which, as shown here, are now the Kirkham Health Centre and offices of the Lancashire County Council's social services department. The complex also included the superintendent's house and a reception house, which still front onto Station Road.

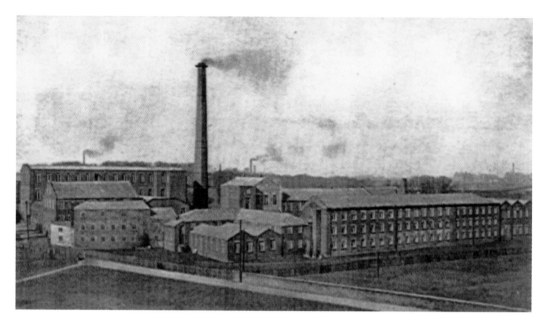

Barnfield – Birley's Mill

As can be seen from the earlier image, the sailcloth factory, erected by John Birley, was extended several times. Its peak period probably came in the early years of the nineteenth century, after which demand for its products declined following the end of the Napoleonic Wars and the development of steam as a motive power for shipping. Closed in the 1890s, it lay idle for a period before gaining a new lease of life as a cotton waste processing plant. Fire finally put an end to its days in 1967. It was demolished and housing was erected on the site.

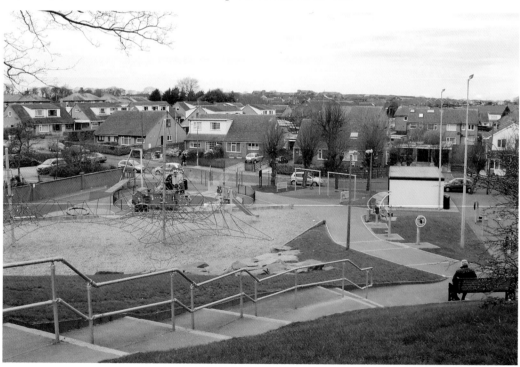

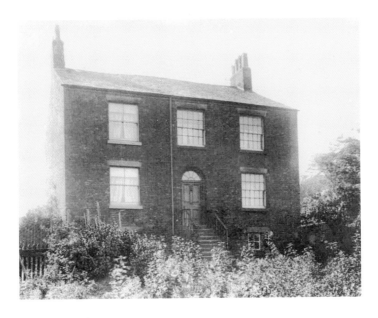

Barnfield – the Apprentice House

The Apprentice House was built by the Birley enterprise to house their apprentices, some of whom came from as far afield as London. Its precise location is not known for certain, but is thought to have been on Barnfield, adjacent to the sailcloth mill (see page 42) and on land now occupied by the 1930s houses. Built by the Kirkham Urban District Council in a style to be found elsewhere in the town, many of these are now privately owned.

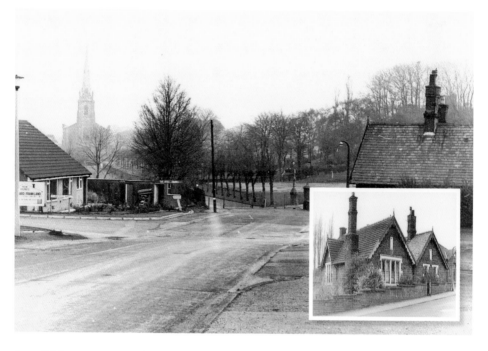

Barnfield – Entrance to the Memorial Gardens

The path leads through the Memorial Gardens to the north end of Church Street and St Michael's church, which is visible in the distance. On the right of the older image can be seen Master Henry's counting house, shown in the inset. The house took its name from Henry Birley, owner of the mill in its later days. A subsequent owner was Mr Fred Felton, who was responsible for demolishing the mill chimney.

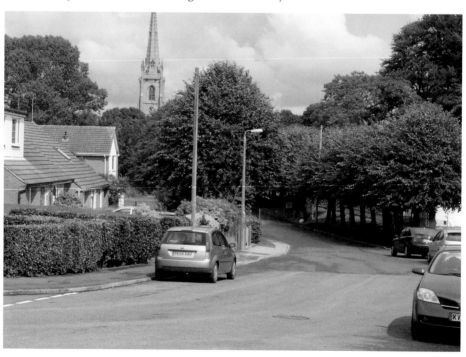

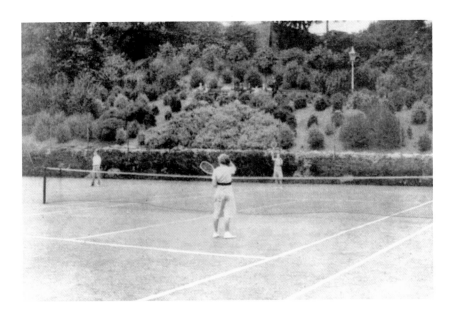

Barnfield – the Tennis Courts

Laid down by the former Kirkham Urban District Council, the tennis courts and their pavilion stood unused and neglected for some years, until they were replaced by modern play equipment for the children of the town. Following the formation of the Friends of Kirkham Parks, considerable funds were raised and additional equipment installed on the adjacent open space. The path to the left of the modern image leads to the war memorial and thence to Church Street.

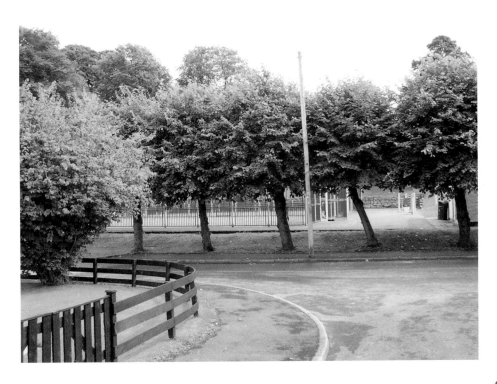

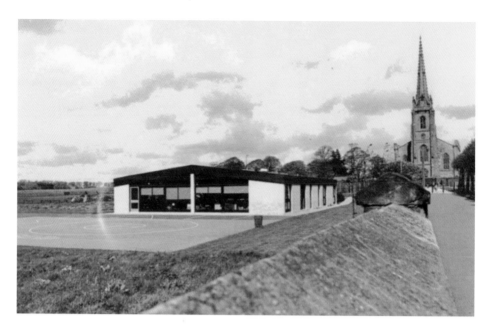

Barnfield – County Primary School Infants' Department

These buildings were opened in the 1970s as an extension to the school's premises on Nelson Street. The intention was to move the whole school to the new site but before this could be done, the new structure was razed to the ground. The scheme was abandoned and the Nelson Street site was developed instead. As the later image shows, the site has reverted to nature.

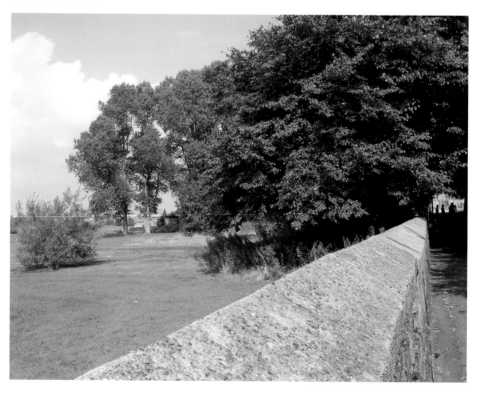

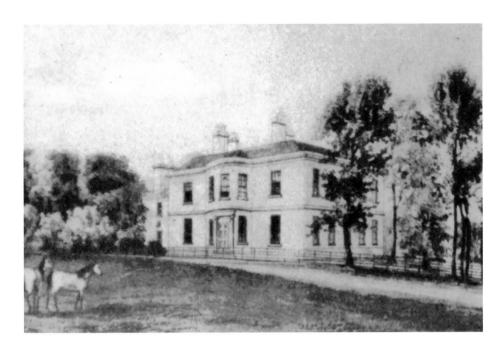

Station Road – Milbanke

One of several large houses in the town to be built and occupied by the Birley family, Milbanke House on the north side of Station Road was latterly owned by Horace Mellor, a relative by marriage and after whom Mellor Road was named. During the Second World War, the house was occupied by the military and subsequently demolished. An estate of privately owned bungalows (seen in the modern image) and the Milbanke Home for the Elderly were erected on the site. All that remains of the former estate are parts of the boundary wall, which can be seen adjacent to the entrance to Milbanke.

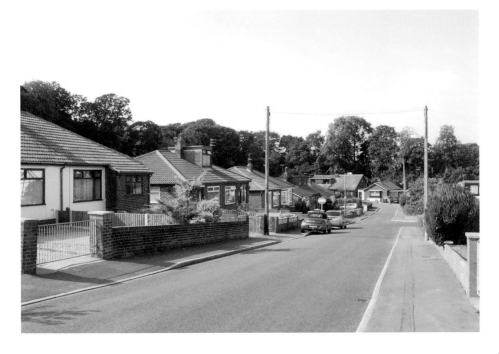

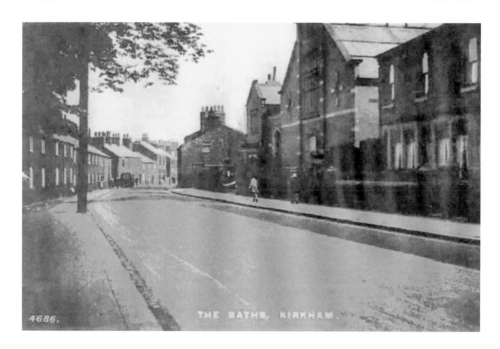

Station Road – Towards Town End

Externally, the town's public baths (on the right) show little alteration when seen from Station Road, although the imposing entrance was bricked up when extensions were made to include a learner pool and additional changing accommodation for swimmers. However, these photographs are of interest as they show the row of small cottages on the left, possibly built by the Birley family to accommodate their employees. Following the demolition of the houses, the land stood vacant for some years, and the site was later used for the erection of purpose-built bungalows for some of the town's older citizens.

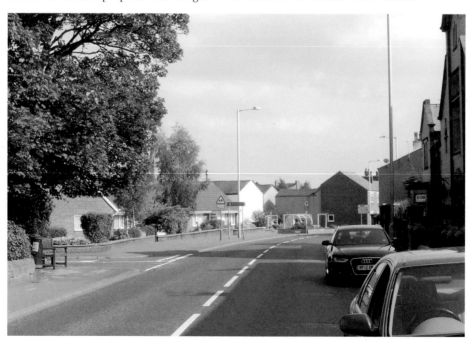

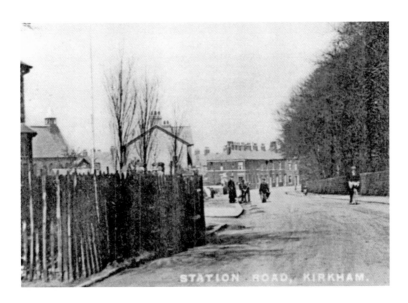

Station Road – Looking West

The boundary wall of Milbanke House and the trees behind it are the link between these two photographs. In the earlier one, the Methodist church, hidden by Westwood, the large house on the corner of Mellor Road, and the 1930s Kirkham Library in the later image, can clearly be seen. Workmen appear to be carrying out some repairs to the carriageway, while the only other road user is a solitary cyclist. In the distance, the corner shop is just visible in both images.

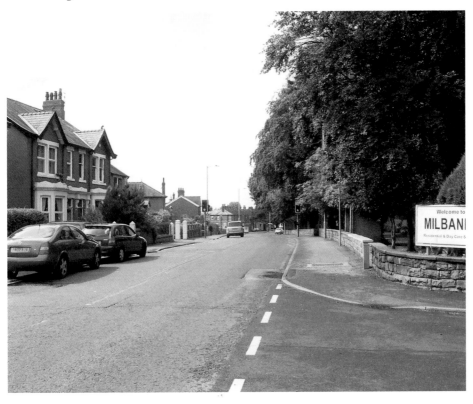

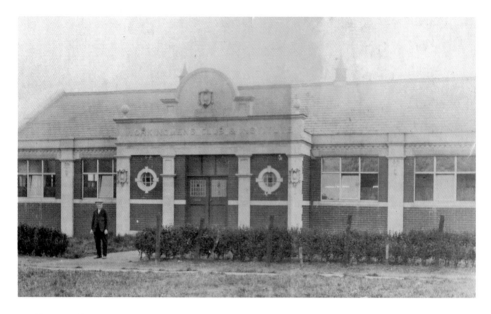

Mellor Road

This road, named after Horace Mellor who had married into the Birley family of Milbanke, connects Station Road with Moor Street and Ribby Road. Halfway along on the western side stood the Kirkham Workingmen's Club and the town's bowling green, where a ginnel led through to Dean Terrace on Station Road. In the early 1990s, the club closed and the building was demolished to make way for a complex of houses and apartments, which took its name, Crown Mews, from the bowling green. Until the 1950s, the southern half of the road was no more than a cinder track and the only building was the town's telephone exchange, now Kingdom Hall, the home of Kirkham's Jehovah's Witnesses. Following the making up of the road, houses were erected on both sides.

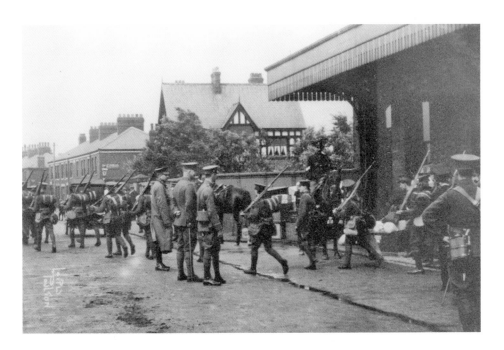

Station Road – the Railway Station

The town's first railway station was on the opposite side of the road to the Railway Hotel. The present building was erected when major changes were made to the line in the late nineteenth century as a consequence of the increase in traffic to the Fylde coast holiday resorts – Blackpool, Fleetwood and Lytham – and the growth of the textile industry when mills were built adjacent to the line. Earlier images in this work have shown Kirkham's First World War recruits. Here, uniformed soldiers are shown as they prepare to march off to their camp on the Weeton Road, Wesham. The principal change to the station building itself is the removal of the canopy.

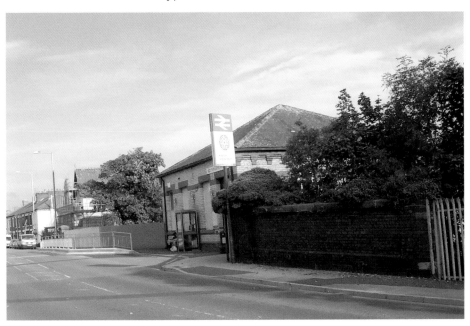

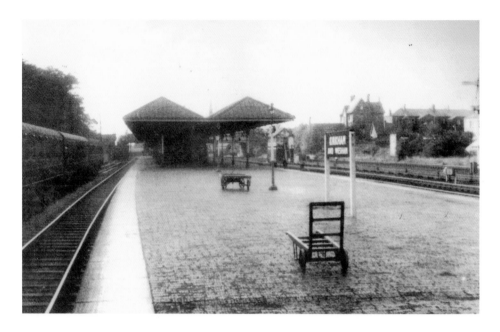

Station Road – the Railway Station Platform

Opened in the 1890s to replace the original station, which was on the south side of the road, Kirkham & Wesham station was designed to cope with the increasing traffic that passed through the railway gateway to the Fylde on its way to the holiday resorts of the coast, and the fishing port and steamship terminal of Fleetwood. Here, multi-carriage trains from the inland towns of east Lancashire – hence the long platform – were split and directed to their respective destinations through the Kirkham North Junction about a mile down the line. The increased use of road transport and the growing popularity of foreign holidays, together with the decline of the port of Fleetwood, considerably reduced the demand for rail traffic; the reduction was reflected in the alterations to Kirkham station and the demolition of its platform buildings. The long platform remains but less than half of it is now in use.

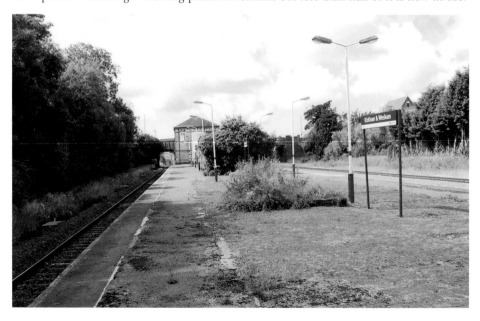

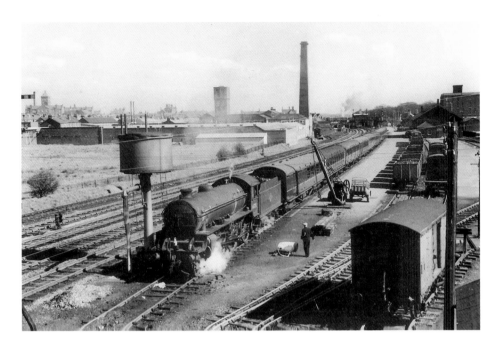

The Railway from the Wesham Bridge

While Kirkham & Wesham station is still the railway gateway to the Fylde, the network and its associated activity have been much reduced, as is clearly evident from these two images. The small warehouse on the right provides a common factor. Brook Mill, which can be seen immediately behind it, has been demolished. On the Wesham side of the track (left), Fox's Biscuit Factory, originally a textile mill, has greatly expanded, although the chimney and water tower of the former cotton mill have gone. The *William Henton Carver* steam engine heads an eight-coach excursion train to the coast from Yorkshire to Blackpool.

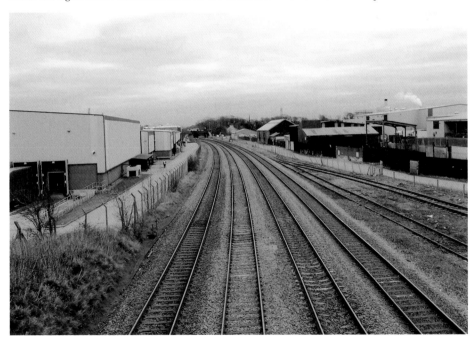

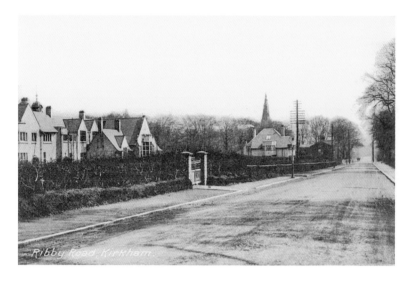

Ribby Road

Unlike the town centre, Ribby Road has changed little over the years. The grammar school moved to its present site at the west end in 1910, and although there has been considerable building work, particularly since the school gained independent status in the 1970s, its façade, covered in Virginia creeper, has remained unchanged.

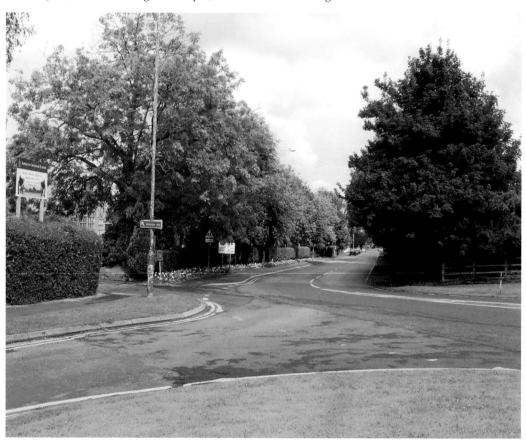

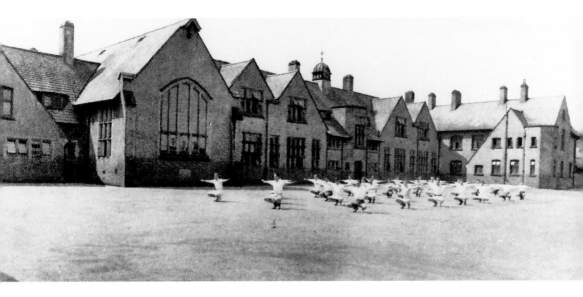

Ribby Road – Kirkham Grammar School, the Quad
The rear of the school seen from the playing fields. The Tudor style of the building recalls its
foundation in 1549 as a free grammar school for the children of Kirkham. Some later pupils are
seen exercising in the quad before the school opened extensions in 1938, which included a library,
laboratory, art room, gymnasium and changing room.

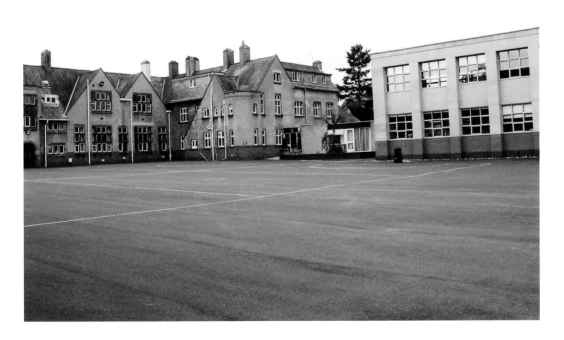

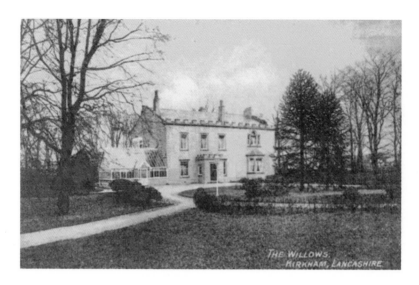

Ribby Road – The Willows Presbytery

The Roman Catholic church, dedicated to St John but known locally as The Willows because of the nearby trees, was opened in 1845 to replace a smaller chapel dating from 1809. The original presbytery, which included a small chapel, stood at the far end of the church grounds. Its size and age made it unsuitable for modern use and, like the old hall and school, it succumbed to the bulldozer's attentions. A new building, including both a home for the clergy and a meeting room for the parishioners, was erected adjacent to the church itself.

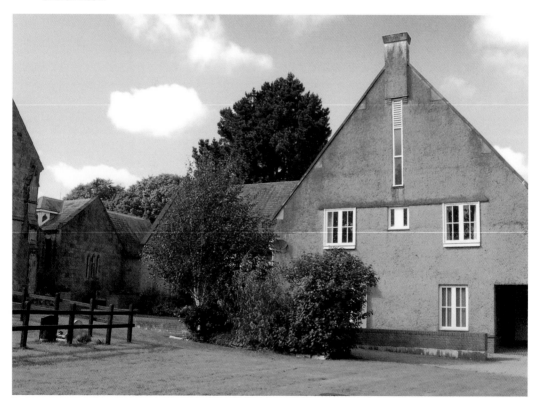

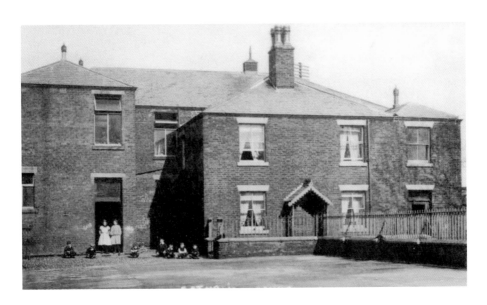

Ribby Road – the Willows School

Opened in 1826 on the corner of Ribby Road and Bryning Fern Lane, and extended in 1871 and again 1894, the school taught both boys and girls. Following a drop in pupil numbers, part of the building that faced onto Ribby Road was converted to a church hall. Both were demolished following the opening of a new school on Victoria Road. Houses were erected on the site, and a new club building opened on the opposite side of Bryning Fern.

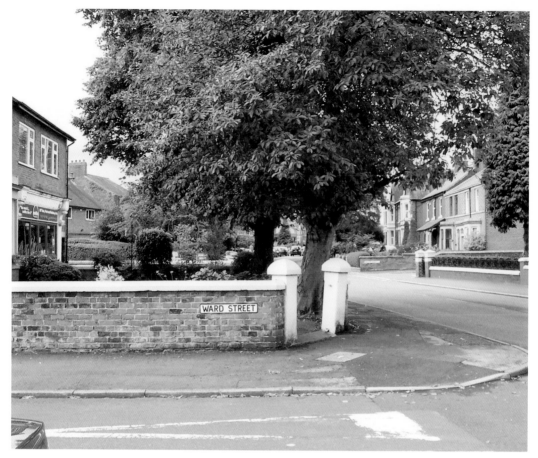

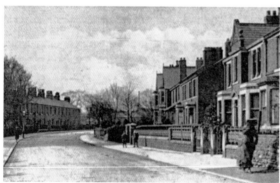

Ribby Road from Moor Street

Mellor Road appears to be little more than a footpath on the earlier image. Otherwise, changes are small: the carriageway is surfaced with tarmac rather than cobbled, and the street lights are electric rather than gas. The small boys, possibly borrowed from the nearby workhouse, wear shorts rather than longs. Is the long-skirted lady trying to conceal her face from the camera?

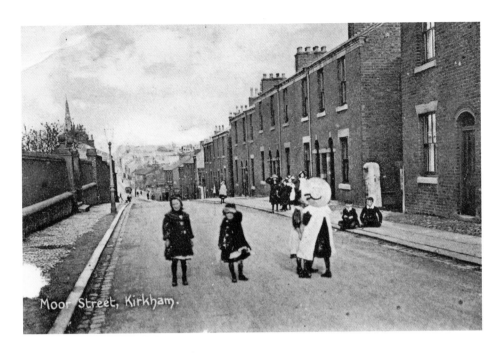

Moor Street, Kirkham.

Moor Street – Looking Eastward

The railings on the wall to the left mark the boundary of the Fylde Union Workhouse site. Following the opening of a new workhouse in Wesham, the workhouse guardians erected cottage homes for the care of their younger charges, the buildings that are now the Kirkham Health Centre and social services offices (see page 41). The children, clearly posing for the photograph and in no apparent danger from motor vehicles, were possibly children from the homes. The railings, in common with most of their kind nationwide, were taken away to be melted down and made into aircraft during the Second World War.

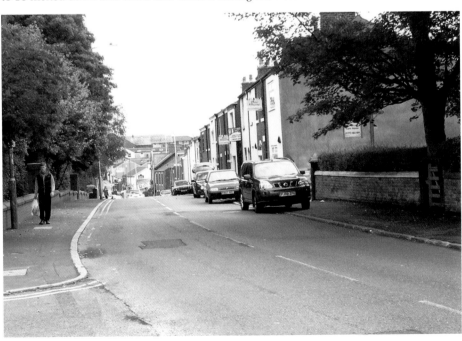

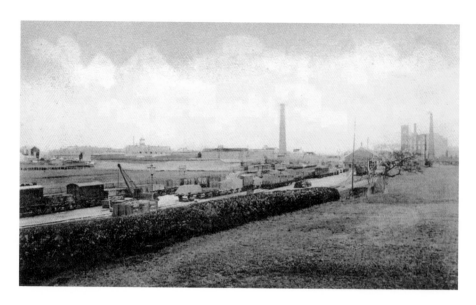

Wesham – General View

These images take a wide view of the township of Wesham. The older image above clearly shows the water tower of the Fylde Union Workhouse and three textile mills – Mosses, on the left, now the home of Fox's Biscuits, and on the right Brook Mill and Selby Mill. The later image, apparently taken from Weeton Road on the way to Weeton, shows a similar view. St Joseph's Roman Catholic church, the workhouse water tower and new houses on Garstang Road North are visible in the background. There appears to be a military tented encampment on the land between Weeton Road and Fleetwood Road and the troops may well be those seen at Kirkham & Wesham station (see page 51).

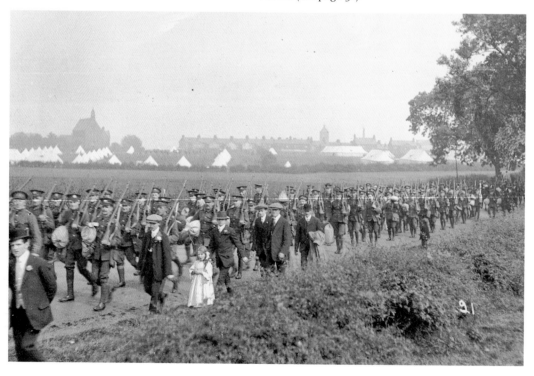

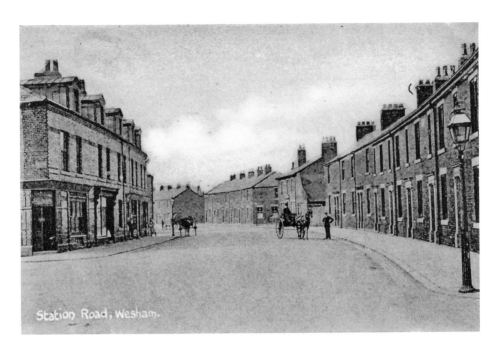

Station Road, Wesham.

Wesham – Station Road from the Station

In the 1890s, the Lancashire & Yorkshire Railway Company relocated the station to its present position and opened up what is now Station Road (as seen here). Laid out on a greenfield site, its width contrasts noticeably with Kirkham's narrow main street. Some of the buildings on the left, all originally shops, have been converted to residential use. As noticed elsewhere, cars replace horse-drawn conveyances.

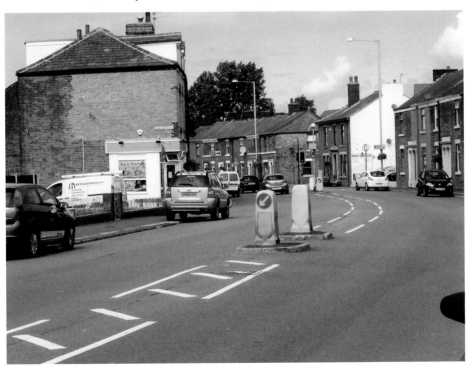

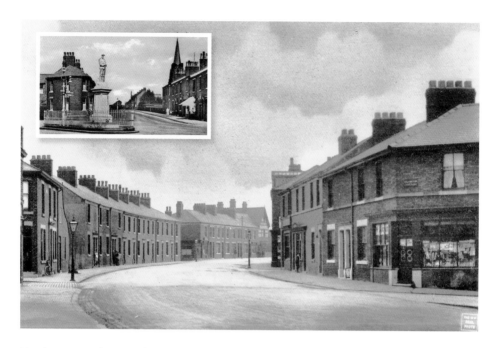

Wesham – Station Road from the War Memorial

Here, the camera has swung through 180 degrees and the photographer has his back to the war memorial, which is shown in the inset. On the earlier photograph, the large house next to the railway station, formerly a doctor's house, then a nursing home and now closed down, can be clearly seen. Corner premises seem to be mostly shops. The war memorial, shown in the inset, stands at the junction of Garstang Road North, Weeton Road and, behind the camera, Garstang Road South. Weeton Road is just visible to the left of the picture.

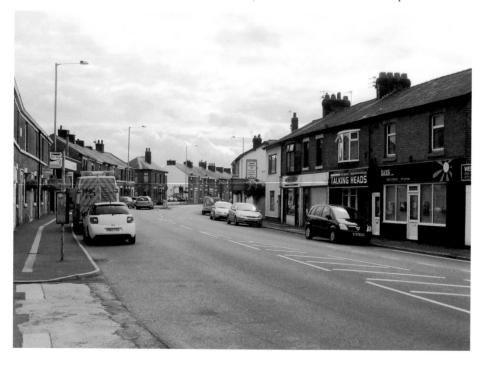

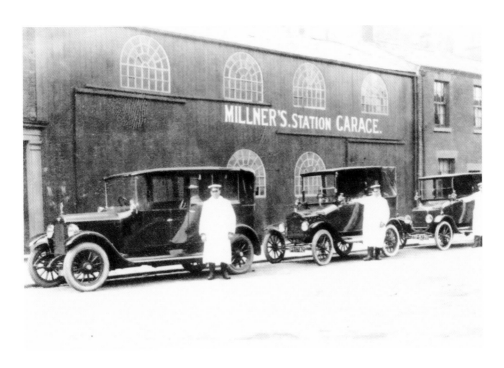

Wesham – Station Road, Millner's Garage

Wesham's provision for the horseless carriage, and a major part of the business appears to have been a taxi service with uniformed drivers. The building was later equipped as a petrol station but following a fire, it now concentrates on the supply of tyres. As noticed in Kirkham, the establishments supplying petrol and otherwise catering for the needs of the motorist have succumbed to legislation and market forces.

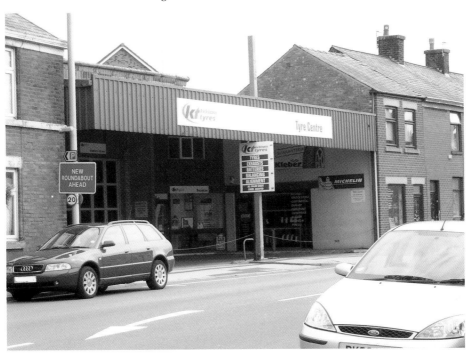

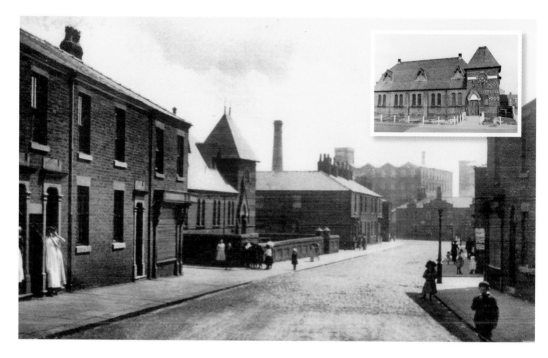

Wesham – Garstang Road South

Garstang Road South, originally called The Wrangway, was formerly the main road through from Kirkham, and was split by the railway line from 1840 where the track was crossed by a level crossing adjacent to the Railway Hotel. The principal buildings are two public houses and the Wesham Institute, now extended and the home of an electrical goods retailer, which was given to the village by Benjamin Whitworth, a Lancashire cotton merchant with interests in the area. Note Brook Mill and Selby Mill in the distance in the earlier image.

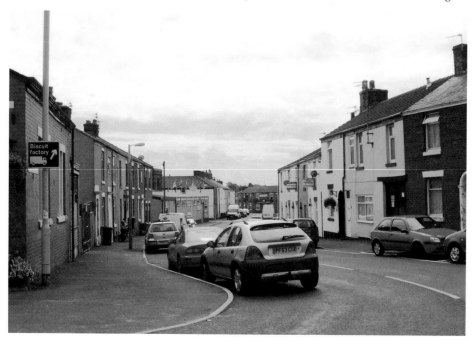

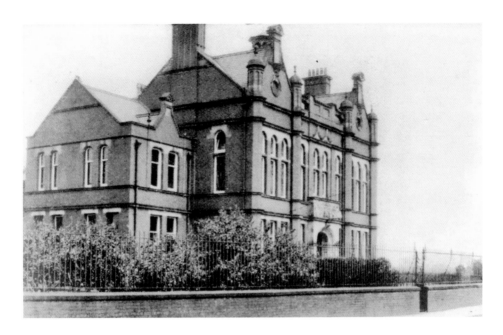

Wesham – Derby Road, the Fylde Poor Law Union Offices

In the early 1900s, the Fylde Poor Law Board of Guardians decided to erect a new workhouse to replace their outdated accommodation in Kirkham, and they purchased a site in Wesham from Lord Derby – hence the name Derby Road. This building (now demolished) served as the offices of the union, and later fulfilled the same function for the Fylde Rural District Council. In time, it too was no longer fit for purpose, and new offices were erected nearby on the opposite side of the road. Following the abolition of the Fylde Rural District Council in 1974, the offices were taken over by the Fylde Borough Council. Their demolition is now under consideration. The site of the original offices is now a flower bed.

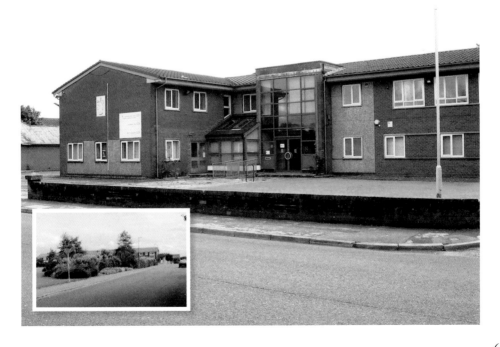

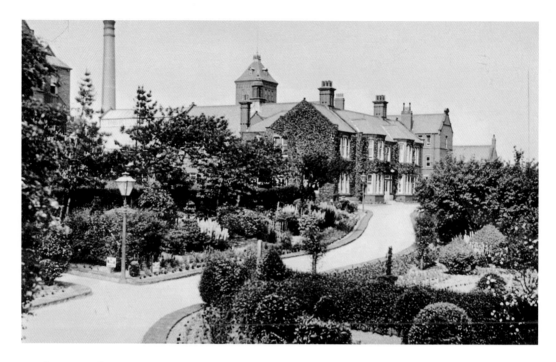

Wesham – Derby Road, Approach to the Workhouse

The entrance to the complex of buildings that together made up the new workhouse – living accommodation, kitchens, sick quarters, offices and so on – was directly off Derby Road, and the buildings spread over an extensive site. Changes in thinking from 1948 as to how the poor should be assisted meant that the buildings were no longer required for their original purpose. Some were taken over by other official bodies, while many were demolished and the land, as can be seen in the later image, used for private housing development. The workhouse water tower can be seen in the centre background of the earlier image.

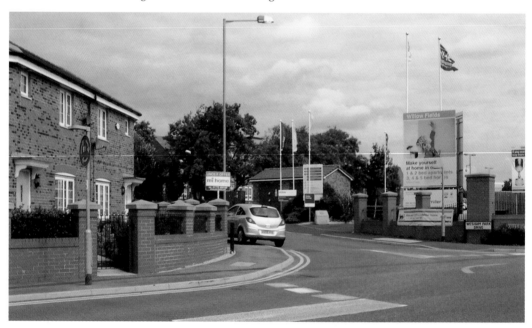

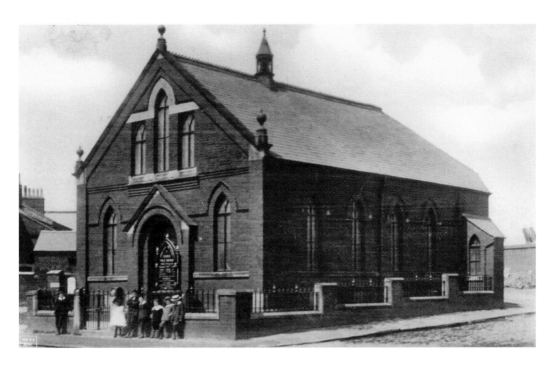

Wesham – the Primitive Methodist Chapel

Opened in 1895, the chapel served the surrounding countryside until the congregation amalgamated with their brethren at Kirkham due to falling numbers. In 1994, the building was in use as a photographic studio and was then converted into apartments, as shown in the later image. Many of the original features have been retained and windows and a canopy over the door added.

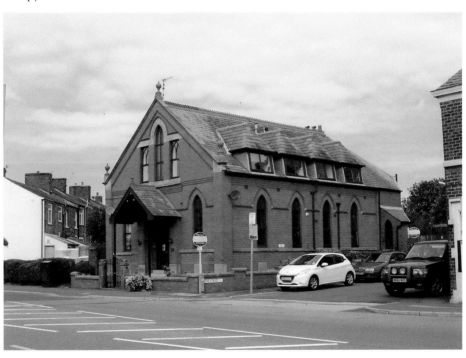

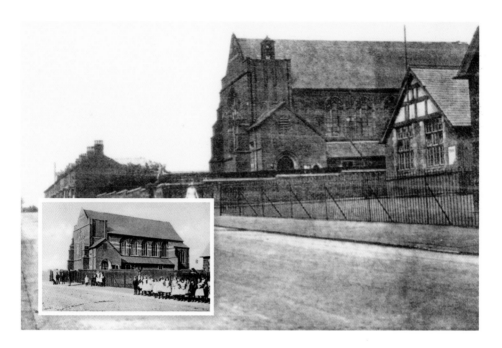

Wesham – Garstang Road North

The Church of England school was an early building on Garstang Road North, dating from around 1880, and for a period it served both as a school and as a place for divine worship under St Michael's, Kirkham, until Christ Church itself was erected in 1892. The tower and spire were added in the 1920s. In the graveyard, there is a plot used for burial of the unfortunates who died in the adjacent workhouse, the coffins being brought through a gate in the dividing wall provided for the purpose. The school itself has been much extended.

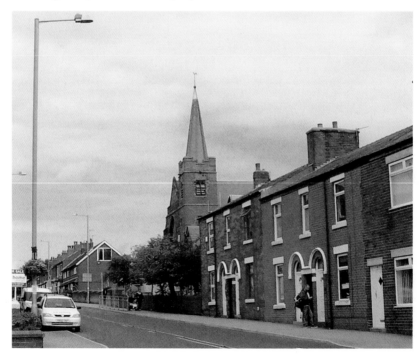

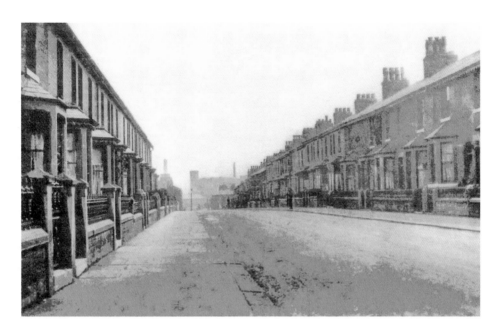

Wesham – Garstang Road North, Looking Southward
These houses, with their small front gardens, are a contrast to those on Station Road, although they are from approximately the same period. Their lack of parking space for private cars, an invention almost unheard of when the houses were built, makes negotiating this road rather hazardous.

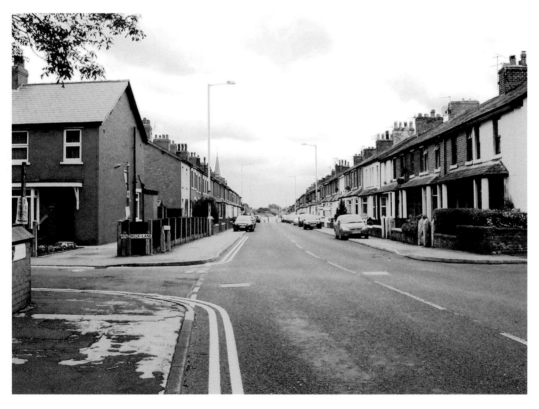

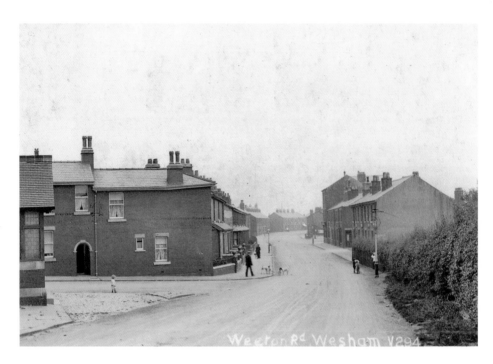

Wesham – Weeton Road from the Lane End

The area at the top of Weeton Road was formerly known as Bloody Lane Ends, as the area was allegedly the site of Kirkham's gibbet – hence the name of the public house that can be seen in the later picture on the left, advertising a well-known and popular brand of ale. Children and dogs are safely playing in the earlier image. Immediately beyond the pub, West View leads to Fleetwood Road.

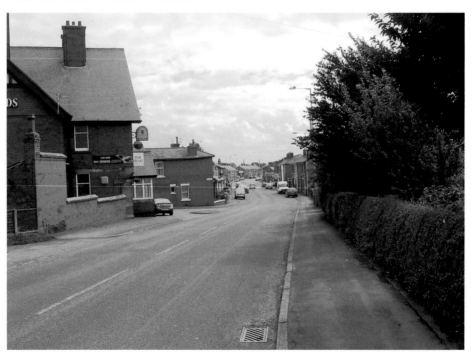

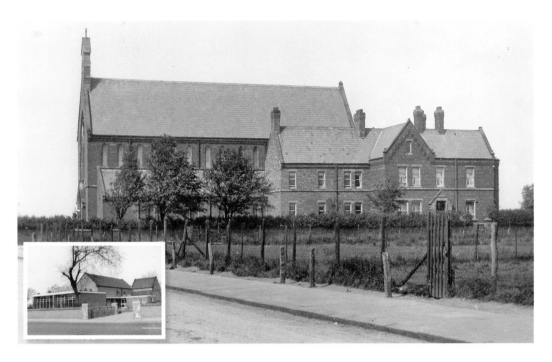

Wesham – St Joseph's Church and Presbytery

Here we see two views of St Joseph's Roman Catholic church and its large presbytery. The land in the foreground, apparently little more than waste ground in both images, was subsequently adopted for housing (see page 69). The inset is a 1960s image of the school that lies on the far side of the church itself.

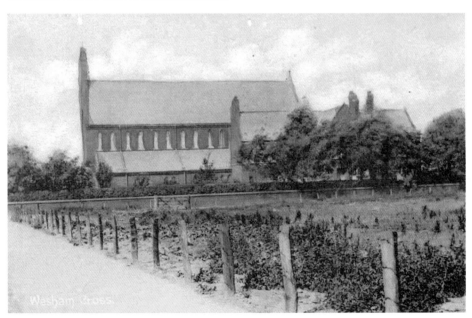

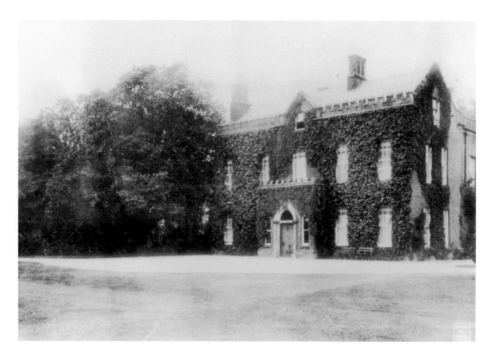

Wesham – Mowbreck Hall

From the fourteenth century, Mowbreck was the property of the Catholic Westby family, until 1890 when it passed to the Earl of Derby. After the Second World War, the eighteenth-century house was purchased by a Blackpool undertaker, who converted it into apartments. Latterly, it served as a nightclub and caught fire. Demolition followed, and the site was developed into its present use as a caravan park for over a hundred residences.

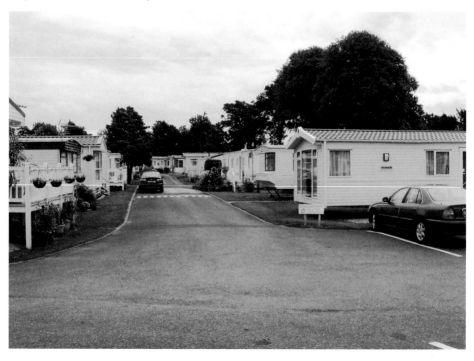

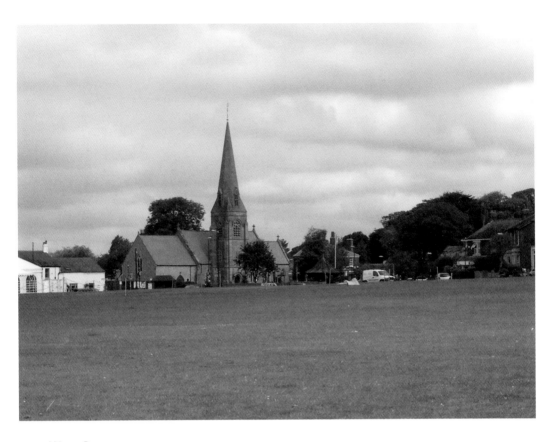

Wrea Green

Wrea Green conforms to the notion of a typical English village, with its large green where cricket is played in the summer and football in the winter. Bordering the green are the church, school, public house and houses of varying ages and styles. The population of the village has increased considerably in recent years, but the several estates of modern houses and bungalows are discretely tucked away behind the older buildings.

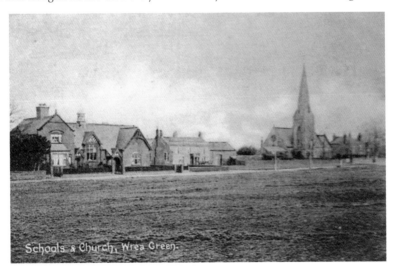

Schools & Church, Wrea Green.

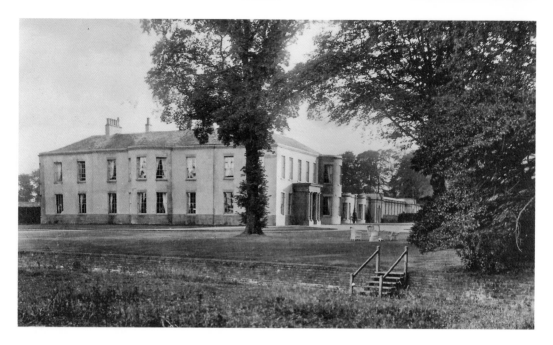

Wrea Green – Ribby Hall

Built by the Hornby family, who made their money as sailcloth manufacturers in Kirkham and who lived there for several generations, Ribby Hall and its estate became a school for deaf children before being purchased by the Lancashire Agricultural Society, who held its annual show there. A couple of years of bad weather during the show week caused the society to rethink its operations and the site, including the hall, was purchased by a local entrepreneur, William Harrison, who converted the hall into apartments, and whose family have developed the estate into one of Lancashire's foremost holiday villages and sports centres.

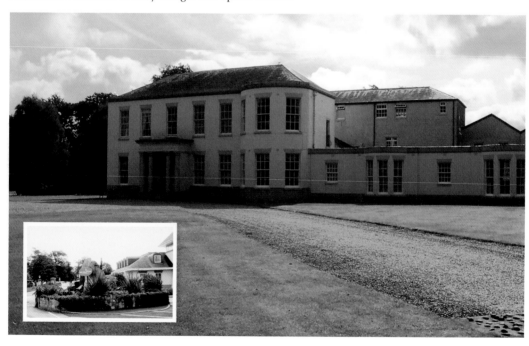

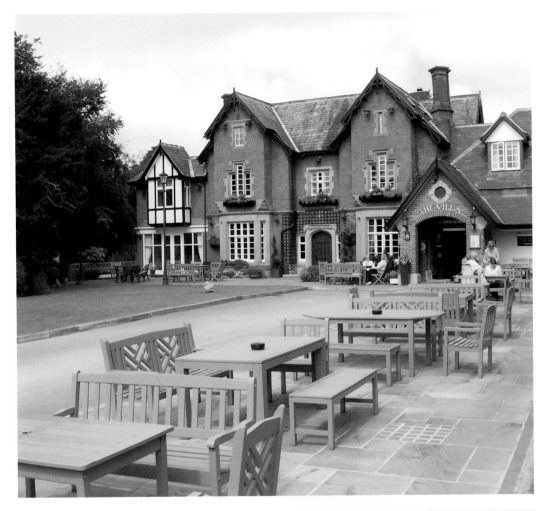

Wrea Green – The Villa

Built in the middle years of the nineteenth century by the Birleys of Kirkham, The Villa was home for various members of the family until the 1950s, when the last of the family to live in the area, Mrs Mary Birley, died. The building was then sold and converted to a restaurant. As can be seen here, the house has subsequently been greatly extended and developed as a hotel, conference centre and a wedding venue. Drinkers and revellers now sit and talk where previously horses grazed.

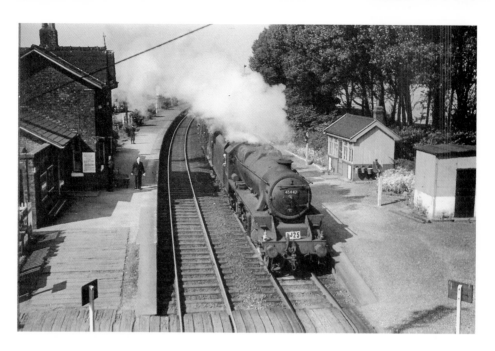

Wrea Green – the Station

One of two stations on the branch line from Kirkham to Lytham, Wrea Green station served the village until the 1960s, when it was closed as part of the Beeching reorganisation of the network. Originally only a single track, the line was doubled, as shown in the earlier image, but was later reduced to only a single track. After closure, the buildings were demolished and the site given over to light industry.

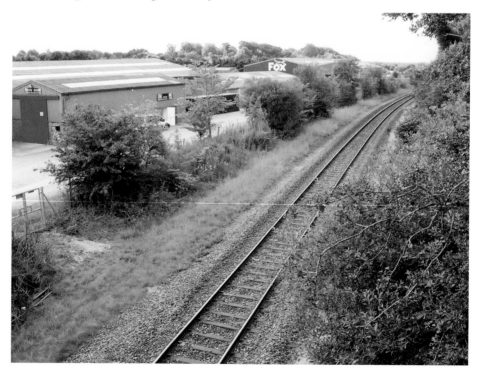

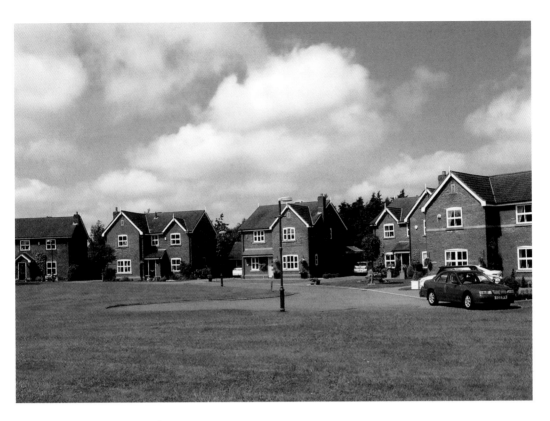

Moss Side Hospital

The modern houses occupy the site of Moss Side Hospital for patients with infectious diseases such as typhoid – hence its rural location away from centres of population. Changes in medical thinking and practice made it surplus to requirements and the bulldozers moved in. The houses are of a style currently popular and noticed elsewhere in these photographs.

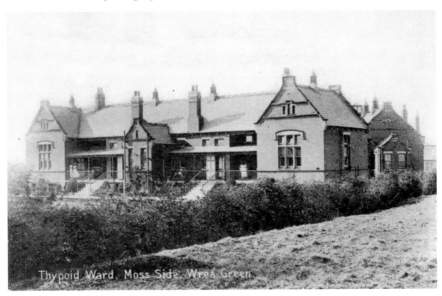

Thypoid Ward, Moss Side, Wrea Green.

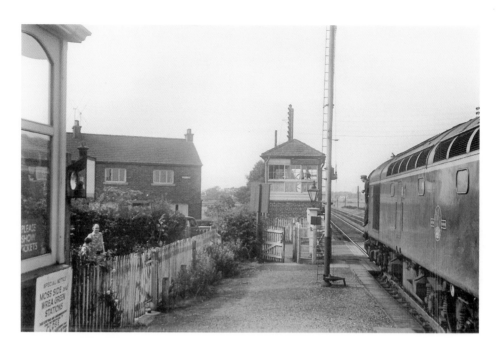

Moss Side Station

Like Wrea Green station, Moss Side station is on the coastal line from Kirkham to Blackpool via Lytham. It was closed as part of the 1960s Beeching reorganisation of the network, but was reopened, it is believed, in response to requests from families of patients in the nearby Moss Side Hospital. The hospital, as has been noted, subsequently closed, but the station remained open. Its level crossing, which was originally operated by hand, is now completely automatic, and the signal box and stationmaster's house have been demolished.

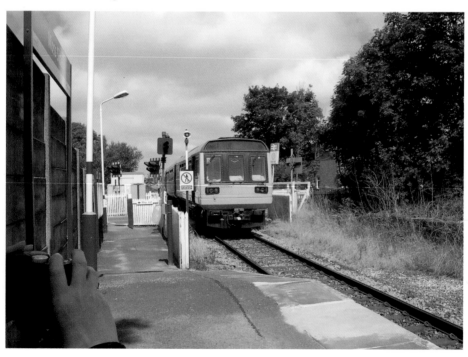

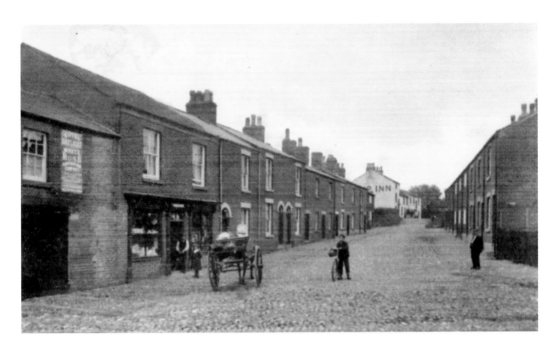

Freckleton – Bunker Street

This road leads to the locally well-known Ship Inn, which is said to date from at least the late seventeenth century, and to the site of the former Freckleton Dock, with its boatyard and rope works where ships unloaded their cargoes. From Freckleton Pool, the River Dow, which lies behind the houses on the left, winds its way across the fields to Dowbridge, Kirkham. Some historians have suggested that this might have been the route by which the Romans came to the latter settlement. At the near end of the row of houses on the left, the Lancashire & Yorkshire Railway had a coal wharf.

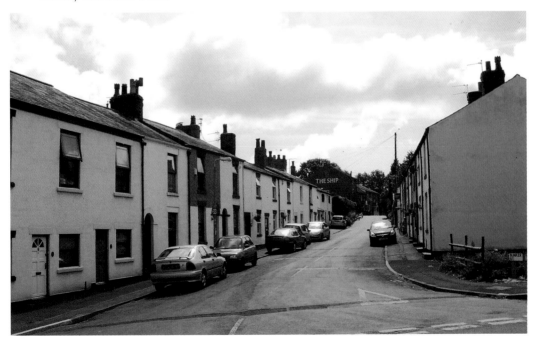

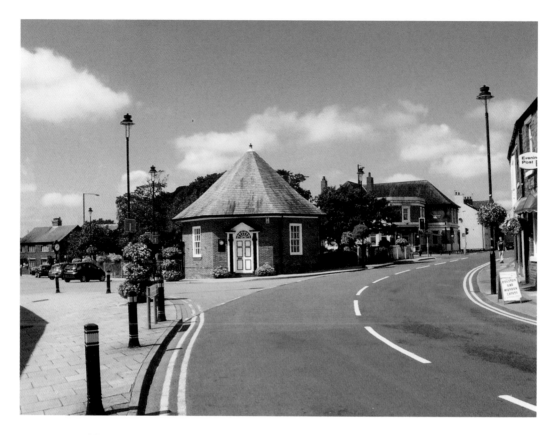

Freckleton – the Square

The small, round building in the distance, latterly a bank, occupies the site of the village smithy. The large building to the left of the bank, which was probably a public house, has been demolished. To the right of the modern image, The Plough Hotel stands on the corner of Kirkham Road. Opposite the bank, the village shop still supplies the needs of the community.

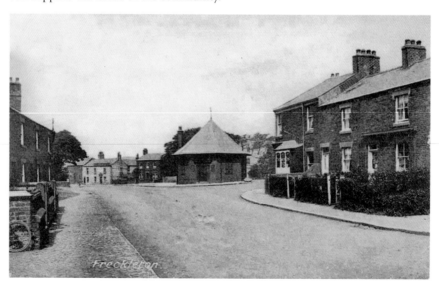

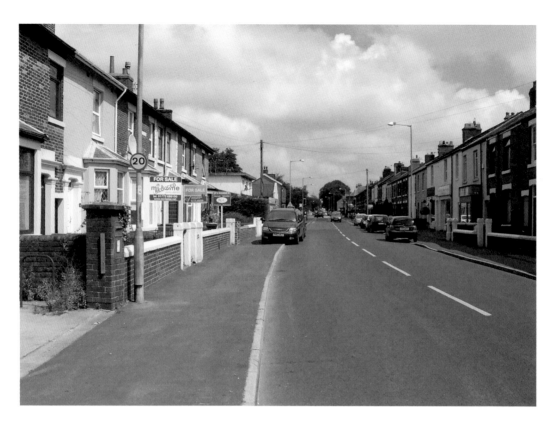

Freckleton – Lytham Road

Another crop of villagers watch the cameraman at work. In the distance in the older image, the chimney of Balderstones Mill, a major employer in the village, pollutes the atmosphere. The mill has been demolished and the lodge filled in. However, its name stone has been preserved and incorporated in the boundary wall of the estate of modern bungalows that now occupies the site.

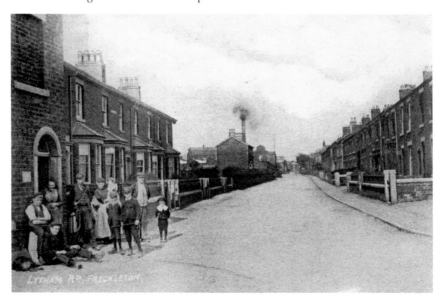

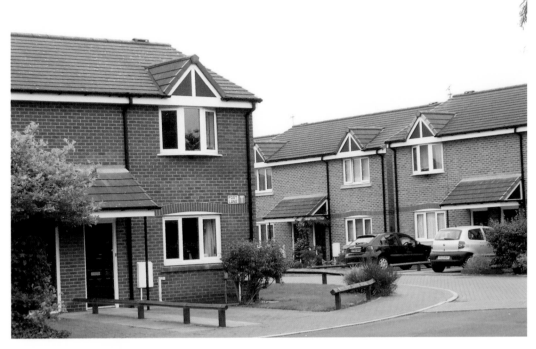

Warton – Peg Mill

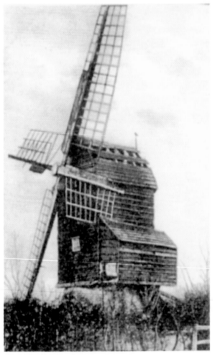

The vast majority, if not all, of the numerous windmills in the Fylde were tower mills that sat firmly on their foundations. Warton's mill is an exception. Said to date from the early eighteenth century and to have been brought across the River Ribble from Rufford, it sat on a wooden post, which allowed the whole structure to rotate into the wind, distinct from a tower mill where only the cap swivelled. In common with that at Kirkham, it fell into disrepair and was replaced by yet another small estate of modern houses whose street names – Peg Way and Post Lane – recall the site's former use.

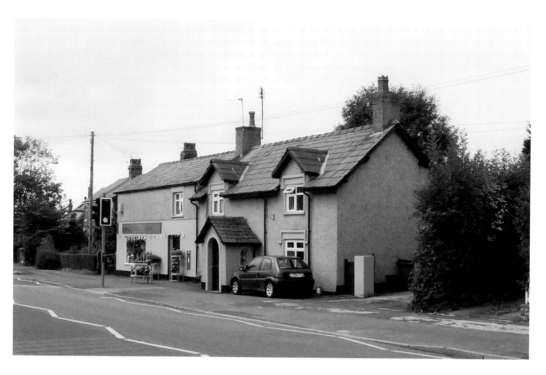

Warton – Post Office

Mrs Rothwell records that the village post office, which was open as early as 1906, escaped the attentions of the bulldozer when Warton Aerodrome was extended for the American Air Force in the Second World War. It continued to serve the village for a period until a change of ownership resulted in a closure of the post office side of the business. As the later image shows, the premises still fulfils the role of a village shop.

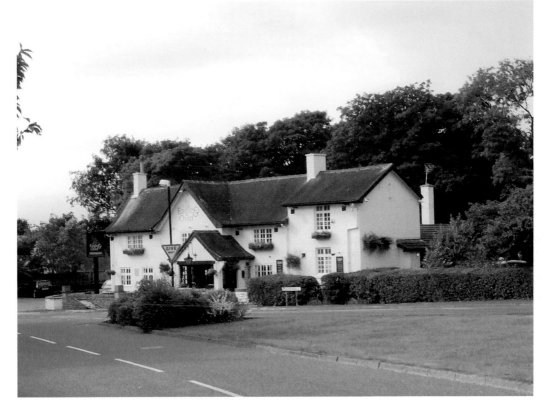

Weeton – the Eagle and Child Inn

Weeton, like Wrea Green, does much to maintain the image of a traditional village, although its green is smaller and its church and school are some distance away. The pub, another popular local hostelry, takes its name from the coat of arms of the Stanley family of Knowsley Hall, who were major landowners in the area. It is possible that some of its regulars were troops from Weeton Barracks, which, having begun life as a RAF station, is now home for various Army regiments.

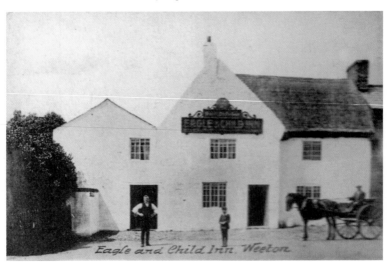

Eagle and Child Inn, Weeton

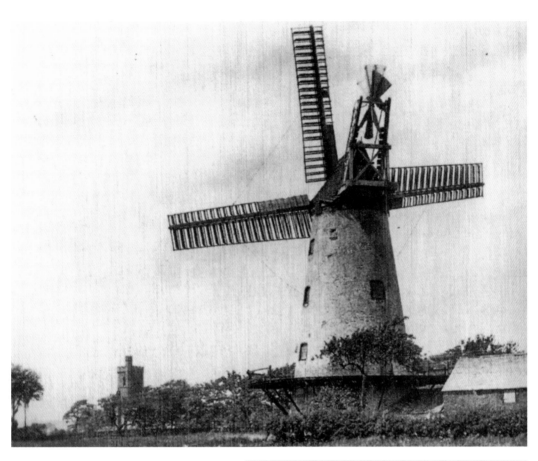

Clifton – the Windmill

Clifton is one of the hamlets that together make up the parish of Lund, the others being Salwick and Newton-with-Scales. These images show Clifton's windmill, a tower mill and one of the tallest in the Fylde, if not in the country. It is said that at one time, it was used as a piggery, and then it was converted to become another popular restaurant and inn, minus its sails.

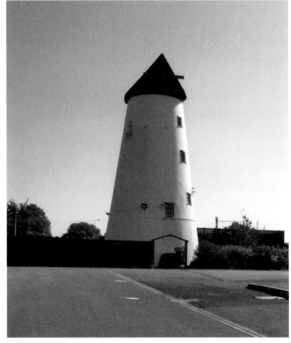

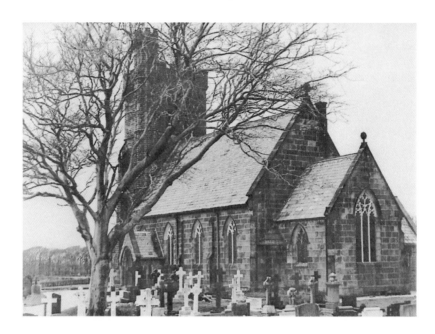

Lund – St John's Church

Dedicated to St John the Evangelist, Lund's church was originally a daughter church of St Michael's, Kirkham, until the area was made a separate parish in its own right in 1840. Although the foundation is possibly fourteenth century, the present building dates from the 1820s, its architect being Richard Roper who was responsible for rebuilding St Michael's at Kirkham. Its furnishings include a Roman altar, formerly used as a baptismal font, and a pair of Queen Anne chairs.

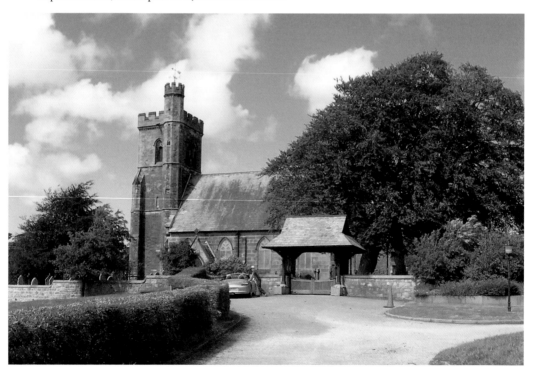

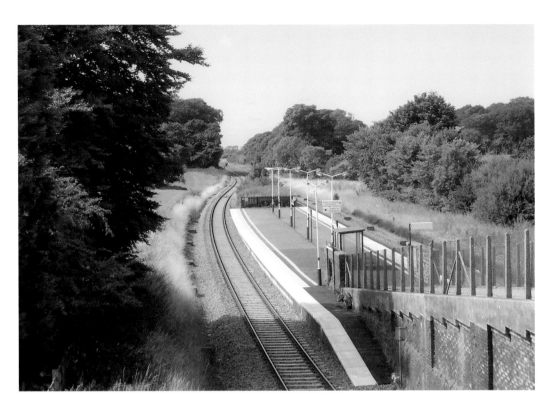

Salwick – the Railway Station

Possibly opened at the instigation of the Clifton family, who were Lords of the Manor and major landowners in the Fylde from the twelfth to the twentieth centuries, Salwick station survived the Beeching cuts of the 1960s, probably due to the proximity of a British Nuclear Fuels establishment, which is merely a hop, skip and jump away and had its own sidings. As was noticed at Kirkham, much of the original lengthy platform has been returned to nature, and the substantial brick buildings replaced by modern glass structures.

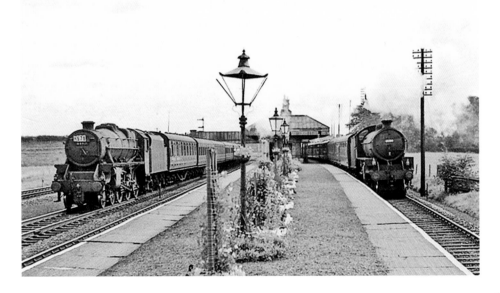

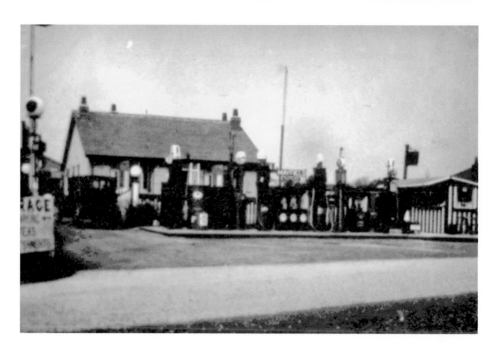

Newton – Mayfield

This is the home of the author's family, who moved there from Manchester in the late 1920s and set up business as *garagistes,* with a small chicken farm on the side. Before the opening of the Kirkham bypass, the garage fronted directly onto the main road from Preston to Blackpool through Kirkham, and on bank holidays and summer weekends, the family were kept busy catering for the needs of holidaymakers, serving teas as well as petrol. In the 1950s, the site was closed following the acquisition of larger premises a quarter of a mile nearer Preston, which became known as Highgate Garage.

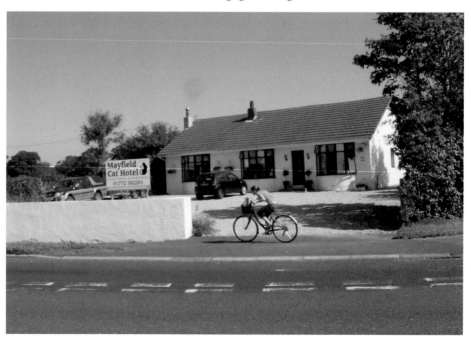

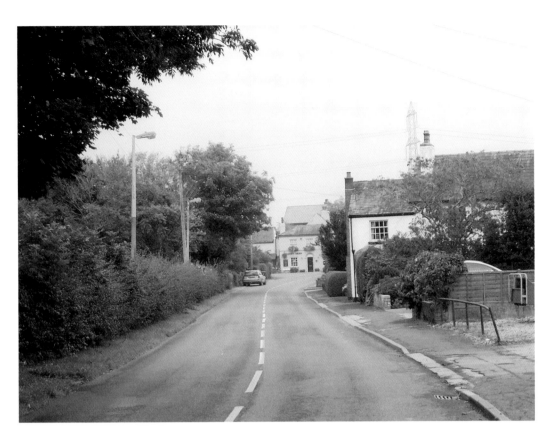

Treales – the Village

Making up one third of the township of Treales, Roseacre and Wharles, Treales is the home of
a church, a school and a pub. A major landowner, as at Weeton, was the Earl of Derby – hence
the name of the pub, the Derby Arms, which is seen here in the background. Some little time
ago, a new licensee changed its name to Papa Luigi's. Not surprisingly, this was not thought to
be a good idea by the local residents. Pressure was brought to bear and the establishment was
reverted to its former title.

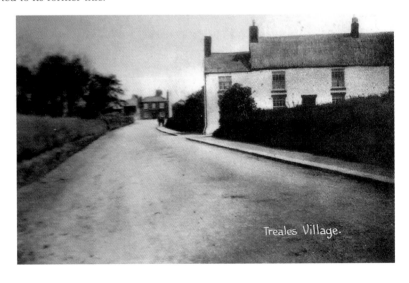

Treales Village.

Acknowledgements

The author wishes to thank the following people of Kirkham and district for the loan of photographs and permission to make use of them: Allen Dearing; Peter Fitton; Mrs Joanne Gardner; Neil Heslip; Robert Kirby; John Sergeant, Lord of the Manor of Kirkham; Mrs Karen Speight; Frank Smith; Mrs Edna Sumner; Andrew Walmsley of St Annes Library; and Roy Wylde. Thanks also to those who allowed me to take photographs of their buildings and to Dr Elaine Bevan and Mrs Julia Brinsley for their help with photographs. Finally, thanks to the staff at Amberley Publishing, particularly Joe Pettican and Sian Griffiths for their guidance and patience.

Bibliography

The following are the major general works on Kirkham and Hooper, Porter, Rothwell and the Victoria County History also cover the villages. For a comprehensive list of books and other items about Kirkham, see the author's *An Historical Tour Around the Town of Kirkham*. With the exception of this title, all are out of print but should be available for loan through the Lancashire County Library and Information Service.

Fishwick, Henry, *The History of Kirkham in the County Palatine of Lancaster* (Manchester, The Chetham Society, 1876).

Hooper, Roy, *The Fylde Story* (Lytham St Annes, Fylde Borough Council, 1968).

Porter, John, *History of the Fylde of Lancashire* (Fleetwood, W. Porter & Sons, 1876).

Ramsbottom, Martin, *An Historical Tour Around the Town of Kirkham* (Kirkham, Hedgehog Historical Publications, 2012).

Ramsbottom, Martin, *Lund: A Trail of Two Villages* (Kirkham, Hedgehog Historical Publications, 2012).

Ramsbottom, Martin, *A Walk Around Wesham* (Kirkham, Hedgehog Historical Publications, 1994).

Rothwell, Catherine, *Around Kirkham in Old Photographs* (Far Thrupp, Alan Sutton Publishing, 1988).

Shaw, Roland Cunliffe, *Kirkham in Amounderness: The Story of a Lancashire Township* (Preston, R. Seed & Sons, 1949).

Singleton, Francis Joseph, *Kirkham: A Short History* (Kirkham, Kirkham & District Local History Society, 1980).

Victoria Count History, *Victoria County History: Lancashire* (University of London Institute of Historical Research, Reprinted 1966).

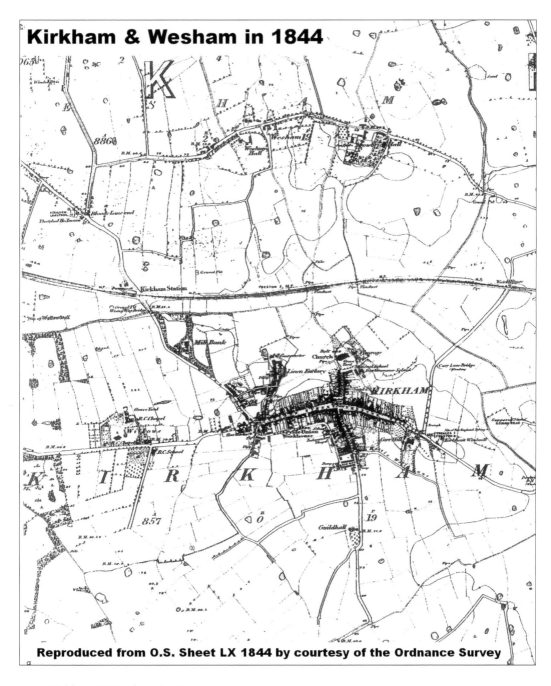

Kirkham & Wesham in 1844

Reproduced from O.S. Sheet LX 1844 by courtesy of the Ordnance Survey

Kirkham & Wesham in 1844

This series of maps, reproduced by permission of the Ordnance Survey, traces the growth of Kirkham and Wesham from 1844 to 1953, via 1894 and 1912. Particularly noticeable is the growth of Wesham and the opening of cotton mills following the arrival of the railway. Public buildings such as churches, schools and the workhouse are shown together with the houses of the leading families, such as Carr Hill House and Millbanke.

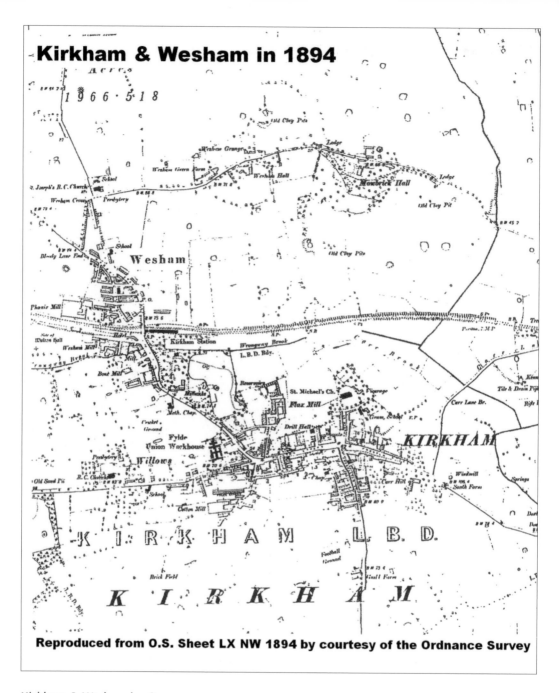

Kirkham & Wesham in 1894

Reproduced from O.S. Sheet LX NW 1894 by courtesy of the Ordnance Survey

Kirkham & Wesham in 1894

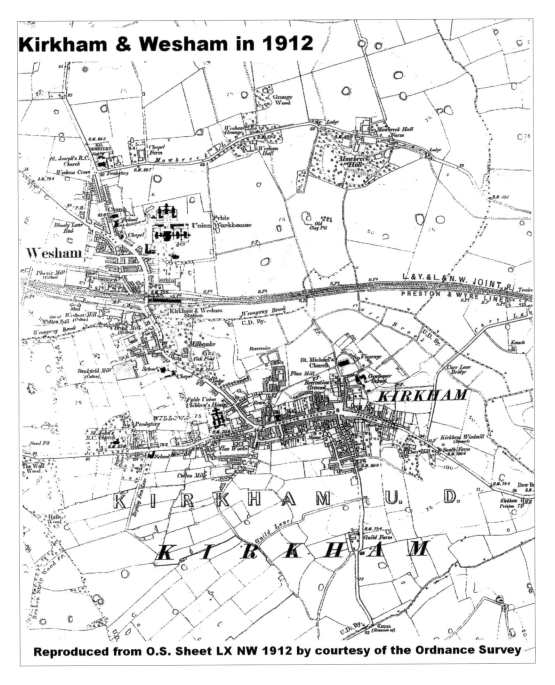

Kirkham & Wesham in 1912

Reproduced from O.S. Sheet LX NW 1912 by courtesy of the Ordnance Survey

Kirkham & Wesham in 1912

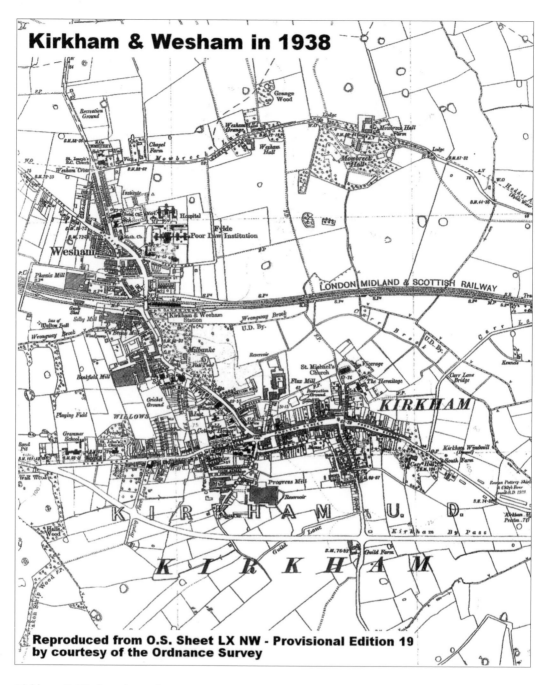

Kirkham & Wesham in 1938